Patrick Heron

Patrick Heron

Michael McNay

ST IVES ARTISTS

Tate Publishing

COVER: *Afternoon Blue: July 1983* (fig.46)

BACK COVER: Patrick Heron at Addison
Avenue *c*.1955
Photograph by Roger Mayne

FRONTISPIECE: Patrick Heron in his studio 1995
Photograph by Julian Feary

ISBN 1 85437 310 2

A catalogue record for this book is available
from the British Library

Published by order of the Tate Trustees by
Tate Publishing, a division of Tate Enterprises Ltd,
Millbank, London SW1P 4RG

Book designed by Isambard Thomas
Cover designed by Slatter-Anderson, London

Colour reproduction by Dawkins Colour
Printed in Hong Kong by South Sea
International Press Ltd

Measurements are given in centimetres,
height before width

St Ives Artists

The light, landscape and working people of
West Cornwall have made it a centre of artistic
activity for over one hundred years. This series
introduces the life and work of artists of national
and international reputation who have been
closely associated with the area and whose
work can be seen at Tate Gallery St Ives. Each
author sets out a fresh approach to our thinking
about some of the most fascinating artistic
figures of the twentieth century.

Acknowledgements

I am especially indebted to Katharine and
Susanna Heron, Patrick's daughters, for their
insights into their father's painting, for the
information they provided, for their hospitality,
and for their invaluable comments on the draft
text of this book. When Patrick's documents
have been catalogued they will form a valuable
archive; meanwhile, they have been swiftly put
in order by his former personal assistant at
Eagles Nest, Janet Axten, to whom I am
indebted for this and other help.
Sandy Nairne and Chris Stephens of the Tate
Gallery read my text, pointed me in useful
directions, and generally helped to keep me
honest. I am grateful to the staff of the Tate
Gallery archive, where most of Heron's papers
are currently deposited, and to the Courtauld
Institute of Art Book Library, which allowed me
to read Andrew Wilson's PhD thesis. Hugh
Stoneman told me about his last day with
Patrick completing *Brushworks*, and kindly
arranged the photography of Patrick's studies
for a motif for the portfolio box. Finally, I thank
Celia Clear and Susan Daniel-McElroy, who
commissioned this book, and John Jervis,
who is that rare bird, a brilliant editor.

Contents

Introduction

Patrick Heron died in March 1999, six months after the end of his retrospective at the Tate Gallery in London, and only a few days into an exhibition on the American artist Jackson Pollock in the same place. Visitors leaving the Pollock show saw Heron's *Azalea Garden: May 1956* (fig.1), which had been temporarily hung near the Tate's entrance hall with a placard inscribed in loving memory, placed there by an institution to which Heron had been both champion and tormentor, sometimes simultaneously. *Azalea Garden*'s gauzy curtain of colour, rich and subtle, assured but unassertive, overlaid with gleaming strokes of white, seen after Pollock's dense, closely woven, clamorous canvases, said everything about the European achievement in contrast to the American. In the words of the American writer John Updike, the Abstract Expressionists 'worked on a heroic scale, and made heroic breakthroughs into sublime simplifications – Rothko's hovering rectangles of colour, Kline's sweeping bars of black, de

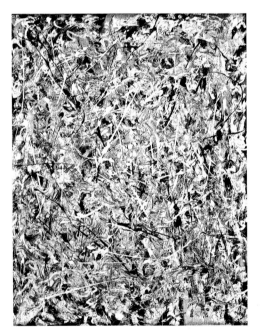

Kooning's infernos of flickering, flashing strokes, and above all Pollock's epic drips'.[1] With Heron, however, a dialogue moves seamlessly between him and Matisse and Bonnard and Braque and back again. Heron's retrospective was a revelation, the summation of a long and varied painting career centred on an unchanging sensibility – the galleries were full of colour, light and space in continuous flux. Pollock's after-death career had been a triumphal progress, his Tate exhibition an apotheosis. The earth moved for Pollock (fig.2).

Why, then, insist on the comparison when the two are far apart? One reason is that Heron went looking for the challenge. He was a pacifist in life; but he was a pugilist in polemic. He had welcomed the American eruption into the arena of abstract art in the 1950s, had been liberated by it, but he grew to dislike the hyperbole that danced attendance. Heron felt certain that his own achievement was as central to later twentieth-century art as the work of the Abstract Expressionists. His views became growingly persuasive over the years, but still

1
Azalea Garden: May 1956
Oil on canvas
152.4 × 127.6
Tate, London

2
Jackson Pollock
White Light 1954
Oil, enamel and aluminium paint on canvas
122.4 × 96.9
The Museum of Modern Art, New York. The Sidney and Harriet Janis Collection

the prevailing view today, even in England, is that somehow the big Americans, Mark Rothko, Jackson Pollock, Willem de Kooning and Robert Motherwell, are more important. I hope in these pages to show that Heron was right and the received view is, well, received. As *The Times*'s obituary summed up Heron's work: 'In the ideal museum of twentieth-century art, his best colour paintings will be on the wall between those of Matisse and those of the Americans Mark Rothko, Ellsworth Kelly, Kenneth Noland and Barnett Newman – with the German Expressionist Emil Nolde not too far away. And there they will continue to sing.'[2]

Heron's career was played out against a post-war background of growing American hegemony worldwide, cultural as well as military, political and economic. At first, though his own intellect and taste had been shaped by Roger Fry, T.S. Eliot and the Parisian avant-garde, and the guiding principles he formed when he was young would stay with him, Heron broadly welcomed the eruption of the Abstract Expressionists into Europe. His formalist views – amounting to a belief that the abstract organisation of a painting also constituted its principal content – made his relationship with the ringmaster of the Abstract Expressionists, the critic Clement Greenberg, a marriage of minds. But the marriage ended in a heap of smashed crockery as the two fell out, partly over the relative importance of New York and St Ives to the art of the post-war years, but also because Heron began to distrust Greenberg as a critical voice independent of the commercial ambitions of the Madison Avenue galleries.

1956 was the pivotal year in Heron's life. In January he reviewed the exhibition *Modern Art in the United States*, sent to the Tate by the Museum of Modern Art in New York, which had a single room devoted to the Abstract Expressionists. In April, Heron moved to Cornwall, which had been the scene of the happiest times of a happy childhood. In June he exhibited his *Tachiste Garden Paintings* at the Redfern Gallery in London, the first group of his works

3

Charcoal Drawing: Eagles Nest: 1958
Charcoal on paper
45.7 × 71.1
Collection of the Artist's Family

to fully embrace abstraction. This was not a series of coincidences, even though his paintings were not so much related to the American achievement as energised by its confidence in scale and its thoroughgoing abstraction; Heron's real epiphany was the experience of the garden at his new house, Eagles Nest, at Zennor, west of St Ives (fig.3).

Of the English critics reviewing the Americans at the Tate in 1956, only a handful recognised the impact of the Abstract Expressionists: principally Basil Taylor, in the *Spectator*, and Heron himself, in New York's *Arts Digest*. After describing Pollock as a 'major phenomenon' and 'already, surely, one of the most influential painters living', Heron added: 'But I am worried by the indefinitely extended web or transparent veil effect: one never comes up against a resistant plane … Consequently there is a strange denial of spatial experience.' In an upbeat conclusion, Heron wrote: 'We shall now watch New York as eagerly as Paris for new developments (not forgetting our own, let me add) – and may it come as a consolation rather than a further exploration.'[3] The consolidation was not to be: that August Pollock died in a car crash.

Heron's cautionary words on Pollock's achievement read as truly today as they did in the mid-twentieth century, and are central to understanding Heron's own practice. The catalogue for his Tate retrospective in 1998 was covered emblematically with *Vertical Light: March 1957* (fig.29) – emblematic because it was one of the first of Heron's stripe paintings to be shown, one of that sequence of which he was to say, 'I thought I was doing the most extreme paintings in the world.' Emblematic, too, because they were painted years earlier than the stripe paintings by the American artist Morris Louis, and it was implicit American claims about the primacy of their man's art that first precipitated Heron's falling out with Greenberg, ending in a famous polemic in the *Guardian*. The newspaper's arts pages commissioned 2,000 words (a big piece for the smaller papers of 1974); Heron wrote 14,000 words. There was nothing for it but to clear the decks and publish the lot, spread over three days.[4] Heron was a persuasive man.

Ultimately though, his brush was mightier than his pen. For all its varieties, his painting remained in the succession of Bonnard and Matisse, and in the landscape and light of the Penwith peninsula in Cornwall. Art, he said, had to be universal but rooted in locality. Cornwall became his locality and he fought over its landscape when it was threatened by developers or by the armed forces wanting stretches of land for training, and he filled his paintings with its light. His wise and encouraging parents had kept his drawings from the age of three. The child was father of the artist for, as Heron himself recognised, his painting in old age retained some of the manner in which he had expressed his direct vision in pencil in early childhood; each departure by the mature painter was the mark of an adventurous spirit in being, in the words of the younger abstract painter Alan Gouk about Heron, 'a true beginning again'.[5]

In writing this account of Heron's life and work I have not followed his own practice of opposing the term 'figurative art' to his own preferred term, 'non-figurative art', for although, as Heron maintained, all art is abstract – and he was concerned to differentiate varying forms of abstract art – such terms as figuration, non-figuration, objective, non-objective, abstract-figuration, figurative-abstraction can begin to sound like Polonius on a bad day. 'Abstract', used to denote non-figurative art, is commonly understood in context and will have to do.

1
Journey into Space

Designing a best-selling fabric at the age of fourteen is, by any standards, starting early. Patrick Heron did it and this success came back to haunt him, much as Matisse had been pursued throughout his career by the accusation of superficiality after saying that he dreamt of an art that was 'something like a good armchair which provides relaxation from physical fatigue'.[1] Later in life, Matisse said that an artist would do well to cut out his tongue before taking up brushes professionally. As an artist, Heron was patronised as soon as his paintings moved into abstraction by critics who suggested that his work had become decorative: 'merely' being the hidden sub-text, and not always that well hidden either. A barbed review of Heron's first exhibition of abstract paintings by the art critic John Berger included this unconcealed if infelicitous put-down: 'A girl could make them lovely by wearing them as a dress.'[2] But Matisse's advice to painters was not a prescription to appeal to Heron. He fought back, scorning

4
Design for Scarf: 1934 [Melon]
Watercolour on paper
40.6 × 39.4
Collection of the Artist's Family

critics who, like Berger, thought of decorative art as somehow inferior to the real thing, and turned the tables by accusing them of superficiality. Applied decoration remained part of Heron's career project: late in life he would design silk neckties and scarves for sale during his Tate retrospective, banners for the Tate shop at Millbank, more banners up to thirty metres deep for the Chelsea and Westminster Hospital in London, and a kneeler for the City of London church of St Stephen Walbrook, to surround the altar by Henry Moore.

Patrick was born in Yorkshire, in the Leeds suburb of Headingley, on 30 January 1920. His father, Thomas Heron (fig.5), was a blouse manufacturer who had set up his own business in the neighbouring town of Bradford at the age of nineteen. Thomas Heron was also a god-fearing pacifist, an idealist, a Fabian, and a member of Leeds Arts Club, all of which heritage he handed on in one form or another to his son, except his Christianity. Patrick's mother, Eulalie, was visually sensitive and deeply responsive to beauty, and the couple moved in avant-garde circles; they commissioned hand-made unvarnished oak furniture from the craft workshop of Simpson of Kendal, rugs from the weaver Ethel Mairet, and lamps from Omega Workshops. They were friendly with the sculptors Jacob Epstein and Henri Gaudier-Brzeska, and the works they hung by the futurist-inspired Leeds painter, B.S. Turner, were Patrick's introduction to modern art.[3]

5
Portrait of the Artist's Father, T.M. Heron: 1943
Conté on paper
50.8 × 40.6
Collection of the Artist's Family

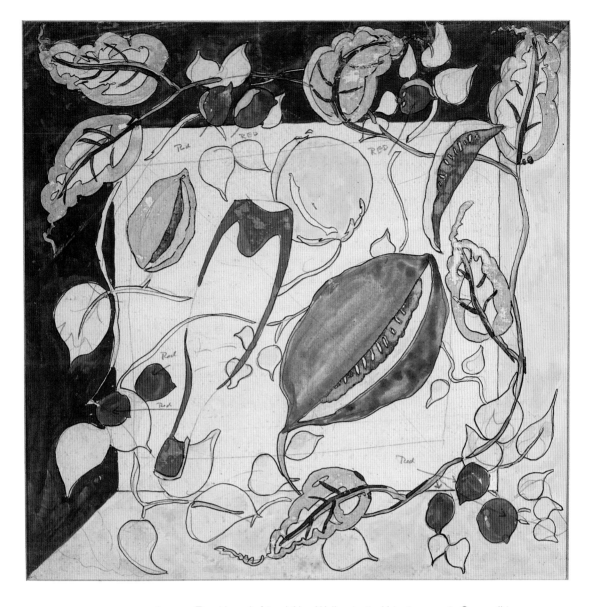

In 1925, Tom Heron's friend Alec Walker invited him to move to Cornwall to manage his textile firm, Crysede Silks. Manufacturing blouses was one thing; to become involved in an enterprise designing and printing fine silks was something else, and much more attractive to someone with Tom's love for art and design. So the family (which was soon to include two younger brothers, Michael and Giles, and a younger sister, Joanna) moved to Newlyn, then to Lelant (from which lofty eminence the seven-year-old Patrick did a drawing of Hayle docks below – or 'Hayl docs', as he labelled it), and finally to a house in St Ives above Porthmeor Beach, the area where Patrick would in later life succeed to the studio of his fellow artist, Ben Nicholson.

At Sunnycroft, a small private school above the town, one of Patrick's schoolfellows was Mark Arnold-Forster. They were to remain friends for life – Patrick, indeed, visited Mark on his death-bed – though, on the face of it, they could hardly have been more dissimilar: Arnold-Forster, later a political

correspondent and leader writer on the *Guardian*, earned a DSO as a motor torpedo boat commander in Nazi-held Norwegian waters, while Heron worked in what he called a 'chain gang', digging ditches in the Cambridgeshire fens, having registered as a conscientious objector. It was Arnold-Forster who would sell Eagles Nest to Heron, the windswept house and garden at Zennor high above the Atlantic a few miles to the west of St Ives. It was to be crucial in the life of the artist.

Another close friendship was between Patrick Heron and Peter Lanyon, who was later another leading figure among the artists around St Ives. At a tender age the two of them founded the Golden Harp Club: Society for the Preservation of Culture in England. President, P. Lanyon, chairman, P. Heron, treasurer, M. Heron. There were no other members. History does not record whether the club succeeded in its aims. But it does show that both founding members went on to become artists, while Patrick's brother Michael discovered a vocation as a Roman Catholic priest, and took the name Dom Benedict.

Patrick maintained that he made his choice of career at the age of three, an improbable claim to artistic precociousness from a man who enjoyed spinning a yarn. However, his parents were proud enough of his ability to have saved his drawings from a very early age, and they were the kind of parents who would never have had a sleepless night over the thought of the elder son becoming an artist. The earliest of Patrick's childhood works saved by Tom and Eulalie are from 1925: there is one of a fully rigged schooner; another is a spare, almost Japanese line drawing of the Old Man of Coniston and Wetherlam in the Lake District. By the age of eight Heron was making astonishingly assured and

6
Wicca Cove (From Eagles Nest): 1928
Pastel on paper
22.8 × 30.5
Collection of the
Artist's Family

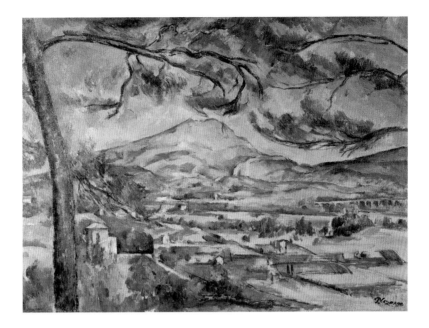

atmospheric studies of the coastal area of north-west Cornwall, including an immediately recognisable drawing of the church in the tiny village of Zennor, and, from a stay at Eagles Nest while the Arnold-Forsters were away for three months, a dramatic pastel of a storm over nearby Wicca Cove (fig.6).

Tom Heron's move to Cornwall had been an immediate success, but after four and a half years, the break-up of Alec Walker's marriage took a heavy emotional toll, and the two business partners fell out. After the split Crysede went into a steep decline. Tom Heron decamped with his family to Welwyn Garden City, the most fully realised of the utopian 'garden cities' originally envisaged by the town planner Ebenezer Howard at the turn of the century. Tom opened his own firm, Cresta Silks, and at once became an enlightened patron of twentieth-century design. He took on the almost unknown Wells Coates to design his Cresta shops, introducing a touch of art deco elegance to, among other locations, Brompton Road and Bond Street in London. For his packaging and promotional material, Tom hired the already famous E. McKnight Kauffer.[4] Paul Nash was only the most famous of the artists who made designs for Cresta Silks.

Heron was to remain grateful throughout his life for his father's support, especially during the post-war years when he had launched his career as an artist. His father continued to pay him for supplying designs, of which *Melon: 1934* was the first and most popular (fig.4), to Cresta Silks. Patrick invoiced for between £1 and £30 for a design. A note on Cresta-headed paper from Tom Heron to his son dated November 1947 shows that for the year up to 5 April 1946, Cresta had paid Patrick £144 7s 6d for designs, and £9 12s 6d travel expenses; and in the year ending 5 April 1947 Patrick had been paid £198 9s plus two guineas expenses. Adjusting to today's currency, the payment for 1945–6 would be the equivalent of a little over £3,300, and for 1946–7 around £4,550.[5] Not exactly riches, especially with a new wife and a baby (Katharine was born in March 1947), but by then Heron was also writing art criticism for the *New Statesman and Nation* and the *New English Weekly,* while broadcasting on art for the BBC's World Service and its nascent Third Programme. And in

October 1947 he had his first London exhibition with the Redfern Gallery in Cork Street.

So Patrick grew up, nurtured his talent and ambition, and met his future wife in the brave new world of Welwyn Garden City. Moving away from St Ives had been a blow, but a blow softened by this meeting with Delia Reiss. Her father was a director of the Welwyn Company, which oversaw the development of the town, and he also invested in Cresta, his new neighbour's business. The nine-year-old Patrick went to Welwyn Garden City High School, and Delia, who was four months younger, was in class that first morning in 1929. 'And that', Patrick was to say later, 'was that.'[6]

The second important meeting came three years later, when Tom Heron sent Patrick to board at St George's School, Harpenden. The art master there was Ludvig van der Straeten ('Vandy' to the boys). 'I hope', Tom Heron wrote to van der Straeten, 'you won't try to teach my son Art.' Vandy had no intention of teaching 'Art' to Patrick; art was a different matter entirely. He recognised high talent when he saw it, and Heron was a willing if not utterly flexible student. His asthma meant that he missed compulsory games and drew or painted instead. Vandy took him through the work of Sickert and Cézanne. One games-less day, the art teacher drove Patrick to London, took him into the National Gallery, and planted him before Cézanne's *Mont Sainte-Victoire with Large Pine* of 1884–6 (fig.7), which was on loan from the collection of Samuel Courtauld.[7]

Sickert's influence on Heron lasted a season. Cézanne's endured for life. Heron's painting of 1936 called *Orchard, Lower Slaughter* already indicates a painter who had been looking at Cézanne – the brush strokes of the treescape lie parallel to the picture plane, the modelling is suggested in the tonality and

8
Winter Orchard: 1935
Oil on board
36.8 × 54.6
Collection of the
Artist's Family

9
Bogey's Bar (Woburn Place): February 1937
Oil on canvas
91.4 × 71.1
Collection of the
Artist's Family

broken touch of the softly modulated umbers, ochres, and greens. Another, called *Winter Orchard: 1935*, shows apple-tree branches tortured into shapes about as close to abstraction as painting can become without being wholly abstract (fig.8).

'For five years Cézanne dominated my adolescent sense of perception,' Heron wrote twenty years after he had painted these orchard pictures. 'I saw with his eyes; I even felt things with his fingers.' In 1956, Heron's *annus mirabilis*, discussing Cézanne's influence on twentieth-century art, he wrote: 'Fragmentation of continuous surfaces, and the tying together of the resultant flat fragments into harmonious configurations – this, in a hundred different guises, has provided the twentieth-century painters with their typical mode of pictorial structure. And it stems directly from Cézanne.' Further, and this, for Heron, and for his work, was crucial: 'it was Cézanne who first extended the formal emphasis to the very corners of the canvas with such uniformity of accent that the picture reads, from rim to rim, as an unbroken, even, unflaggingly rhythmic design. And this all-over stress, this insistent regular pulse from edge to edge, is still general in the best painting at the present time.' So that even in paintings Heron did at St George's School and shortly after (such as *Bogey's Bar (Woburn Place): February 1937* [fig.9], a view of Bloomsbury seen across the café and through a plate-glass window which had some of the brown HP Sauciness of a certain kind of Sickert) there is a sense that the formal emphasis has been extended 'to the very corners of the canvas'.[8]

This was the first and best lesson Heron learned from the man he pronounced was 'a painter without peer in the entire history of art'. But simultaneously he was approaching the apprehension of 'all-overness' from a different direction: *Melon*, Heron said later, 'is much more related to Matisse'.[9] The largest element of this silk, a slice of melon, draws the eye, but is no more than a focus among a scatter of leaves and berries anchored on a square divided diagonally into yellow-ochre and beige halves, with a light-coloured square superimposed at the centre of the design. Unlike Matisse, *Melon* has dated; but this was a first intimation of an influence which was to become central in Heron's painting. Matisse was Heron's master, though at a distance: Heron had met and corresponded with Braque in 1948, and watched

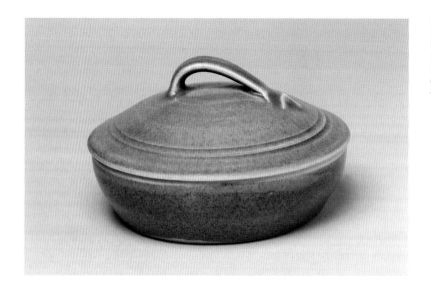

10
Butter dish
Stoneware
Diameter 14.2
Height 8
Collection of the
Artist's Family

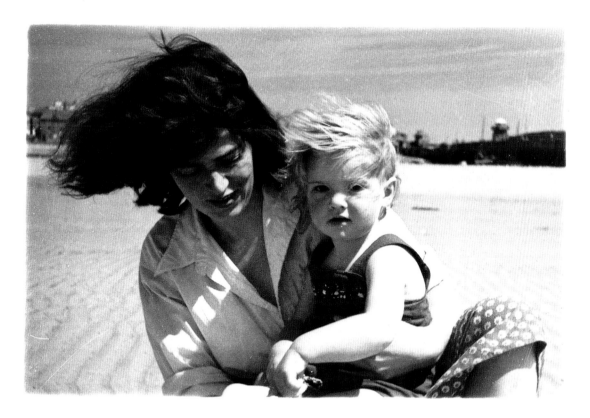

11
Delia and Susanna
on the beach at
St Ives 1951

him at work on his late *Atelier* and *Billiard Table* masterpieces, but in Vence, Lydia Delectorskaya, Matisse's formidable model and minder, barred Heron's entrance.

When war broke out, Heron had already spent a couple of years at the Slade School of Fine Art in London, learning little. The major legacy of his time at the Slade was another of the lifelong friendships at which Heron was so adept, this time with his fellow student, the painter Bryan Wynter. Given his chronic asthma, Heron's wartime service as an agricultural labourer could have killed him as effectively as enemy action – after three years his health broke down enough for the doctors to rescue him, and he went to work at Bernard Leach's pottery studios in St Ives; Leach had received government dispensation to help in shortening the war by making utilitarian objects such as butter dishes. A few items made by Heron are still used at Eagles Nest by his family, including a lovely jade-coloured butter dish (fig.10).

Heron repaid his employer, first by placing a Leach bowl and a dish by Shoji Hamada, Leach's partner, in his lyrical still life *The Long Table with Fruit: 1949* (fig.12), and then in 1952 with an affectionate and perceptive review in the *New Statesman* of Leach's book, *A Potter's Portfolio*. Heron concluded this review by drawing attention to a passage in which Leach writes: 'A potter on his wheel is doing two things at the same time: he is making hollow wares … *and he is exploring space* [Heron's italics].'[10] Exploring space was to be the leitmotif of Heron's life. It would shape his career as a painter, and it would get him the sack from his job as art critic of the *New Statesman*. But the Leach review was his farewell to Leach's world, though the two remained friends. Heron had been content to be a journeyman potter, but it was not in this direction that he was to seek mastery.

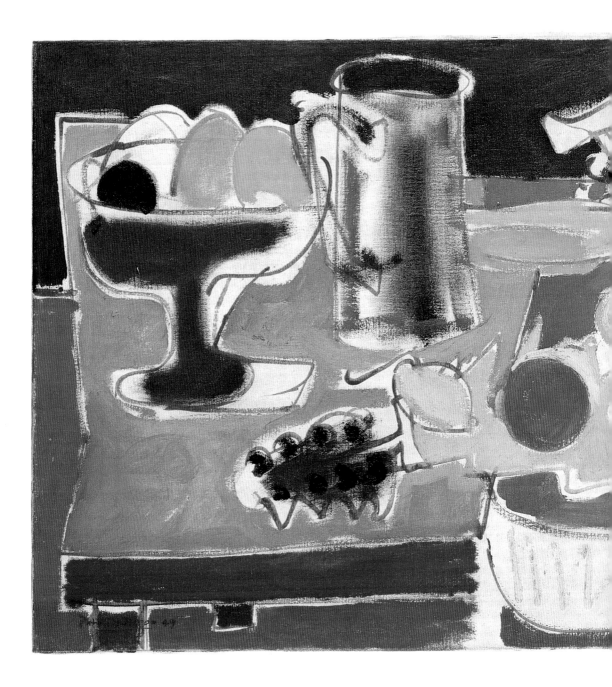

12
*The Long Table
with Fruit: 1949*
Oil on canvas
45.8 × 91.4
Tate, London

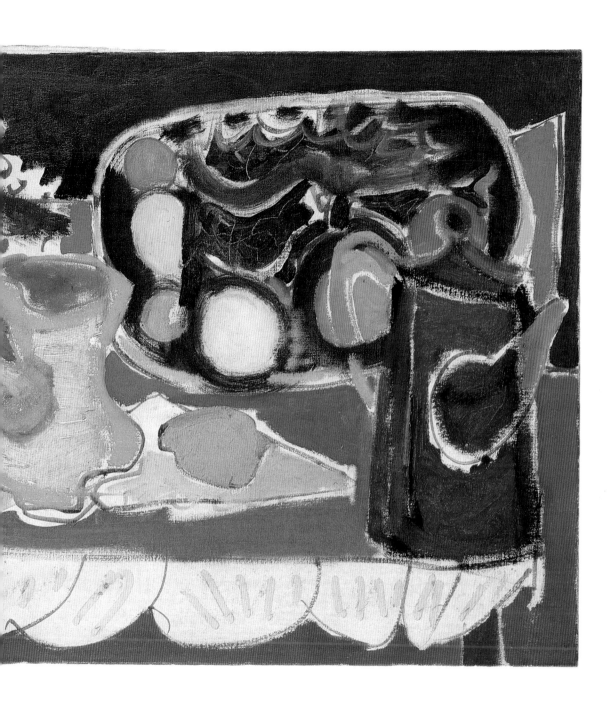

2
The Girl at a Window

The war years had not been a total write-off. During his time at the Leach Pottery in St Ives from January 1944 to March 1945, Patrick Heron met and befriended the Penwith peninsula community of artists: Ben Nicholson and Barbara Hepworth, the writer and painter Adrian Stokes and his wife, the painter Margaret Mellis, Sven Berlin, Naum Gabo, and also John Wells, who was still practising medicine on the Isles of Scilly before turning in his stethoscope at the war's end and becoming a full-time painter. And, in 1943, the last of his three years as an agricultural labourer, Heron had spent leaves of absence in Chelsea at the Tite Street studio of a Slade friend, Adrian Ryan. During these visits he first saw Matisse's *The Red Studio* (fig.13) in the Redfern Gallery, where it remained until 1945 when the managing director, Rex Nan Kivell, sold it to an American for £600. It is now part of the wonderful collection of Matisse paintings in the Museum of Modern Art, New York. John Rothenstein, the director of the Tate Gallery at the time, never even came to see the Matisse before it was sold abroad.[1]

Heron had already encountered the paintings of Matisse, though mostly in reproduction, but during the period that *The Red Studio* remained at the Redfern Gallery he returned time and again. In 1943, on a visit home to Welwyn Garden City, he painted *The Piano: 1943* (fig.14), an oil on paper, not much bigger than an artist's spread hand, of a grand piano in front of the window that overlooked the family home of his prospective parents-in-law across the street. The work has a tentative and unfinished look, but it was important enough to Heron for him to sign and date it. The flat planes, the high-toned red of the piano, the orange of the music case, the green foliage, the brilliant blue of the window frame, all contributed to a freshness of colour that hardly existed in English painting at this time. It was a step forward and Heron immediately realised this. Later, he would claim it as the biggest step forward in his whole life. He gave it to Delia for her birthday – the two married in April 1945, the only way Patrick could get his hands on this seminal painting again, according to one of his brothers.[2]

Later that month, Hitler died in his bunker in Berlin and Heron became one of hundreds of thousands of young men who were at last able to launch themselves into their chosen careers. Delia and

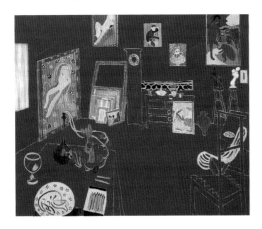

13
Henri Matisse
The Red Studio 1911
Oil on canvas
181 × 219.1

The Museum of Modern Art, New York. Mrs Simon Guggenheim Fund

14
The Piano: 1943
Oil on paper
19 × 27.3
Collection of the
Artist's Family

15 overleaf
Christmas Eve: 1951
Oil on canvas
182.9 × 304.8
Collection of the
Artist's Family

Patrick moved into the top half of 53 Addison Avenue in Holland Park, a London house belonging to Delia's father, though they went that summer to Carbis Bay, St Ives, where Patrick recharged his batteries.

Throughout Heron's life he was loosely regarded as a painter who had developed into maturity through a period of Braque-tinged Cubism, during which he painted interiors like the famous *Christmas Eve: 1951* (fig.15), commissioned for the Festival of Britain, with its shallow space, multiple viewpoints, and patches of colour loosely contained within a linear network. Heron himself maintained both at the time and in retrospect that his colour owed more to Matisse and Bonnard, and he felt that the public thought exclusively of a resemblance to Braque's Cubism (Braque had himself been a Fauve before meeting Picasso, but Heron never mentioned this period as an influence) because he had published one of his first reviews in 1946, a close and highly sympathetic analysis of Braque's latest work. The truth is that Heron was influenced by all three Frenchmen. The seductive blues, pinks, yellows and oranges of the landscapes painted when Heron visited his friend Francis Davison in Antibes over the winter of 1948–9 are clearly post-Fauve. 'One wanted to get off the ground at top speed, and to hell with the influences,' Heron would write many years after.[3] But these paintings are his own, just as Matthew Smith's works were clearly Smiths, and not Derains or Matisses, and the work of the Blue Rider Group of Munich, despite its Fauve fingerprints, bore the individuality of Kandinsky, Jawlensky, Marc and Münther.

There was never a big show of Heron's paintings of the 1940s, so that although works such as *The Long Table with Fruit: 1949* and *Indigo Bay: 1952*,

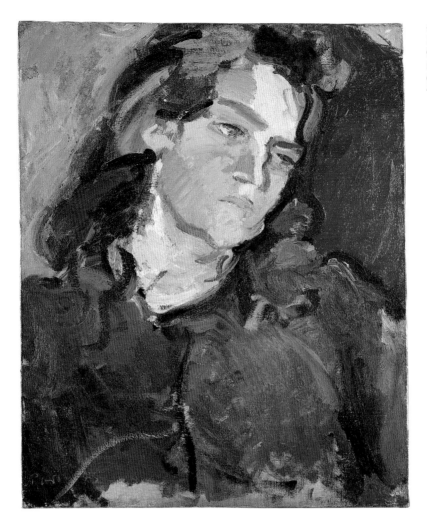

16
Delia: 1945
Oil on canvas
55.8 × 43.1
Collection of the
Artist's Family

which were bathed in the light of Fauvism, were well known, Heron was most often thought of as a post-Cubist painter, not least because he had made a series of portraits from 1947 to 1949 of T.S. Eliot; and in 1950, and in a similar style of full-face and profile views contained within the same composition, he painted a portrait of Herbert Read. These seemed like an illustrative and provincial version of Cubism. So too did *Christmas Eve: 1951*, which for all its brilliant organisation lacks the concentration, clarity and sculptural weight of a Braque. *Girl in Harbour Room: 1955* also has the distracting fault of some of Heron's other work of the period: the naturalistic outline of the girl's figure looks almost as bland as a fashion plate in the context of the network of wiry lines which creates an abstract mesh across the surface (an echo of those late *Atelier* and *Billiard Table* paintings [fig.17] that Heron had seen in Braque's studio). Despite this, the well selected and beautifully hung Tate retrospective of 1998 began the work of undermining the notion of a backwater approach to Cubism in Heron's early paintings by setting up reverberations between these and the very latest works. Visitors could look from *Girl in Harbour Room: 1955* in the first room, with its dabs of colour only loosely related to the mesh of lines, through to the early abstracts in the following gallery, and across to the vividly linear garden paintings of Heron's final years in the last room.

The point that the early work was not derivative but a harbinger of the great work to come was consolidated eighteen months after Heron's death when his dealer, Leslie Waddington, put on a show of twenty-eight works at the Waddington Gallery called *Patrick Heron: Early Paintings 1945–55*. This redrew the map of the artist's figurative period. There were Braque-influenced canvases in the show, including a self-portrait, but there were also the far blue hills of *Juan les Pins from Cap d'Antibes: December 1948* (fig.18), one of the Fauve landscapes painted over the Christmas and New Year of 1948–9; the subaqueous greens and blues and the brilliant lemon yellow of *Gas Stove with Kettle and Saucepan: 1945–1946* (fig.19); the patchwork of colour from blood red to emerald green in the little *Zennor: 1945*; the *Still Life with Red Fish: 1948* (fig.20), with its broad vertical striations of blue and mauve shadow, rhyming with the struts of kitchen chairs on either side of the table and the tall stems of some unspecified flowers in a vase. In the company of these and many others, the more linear paintings began to look like a unified approach to forging a personal style by absorbing the lessons of European painting from the post-Post-Impressionism of Bonnard (fig.25) to the late Cubism of Braque and the Fauve colour of Matisse and early Derain. Most of these paintings were done, not in Cornwall but in Holland Park. In other words, Heron was learning from art and from his visual memory, not directly from nature, and the masters to whom he gave his allegiance were his contemporaries – older contemporaries who today seem as distant as the nineteenth century, but who were still alive and working in the 1940s and 1950s: Matisse, Braque, Bonnard, Derain. And, indeed, Picasso.

In St Ives itself, the three artists who were recognised as world class were Ben Nicholson, Barbara Hepworth and Naum Gabo. They were also the most

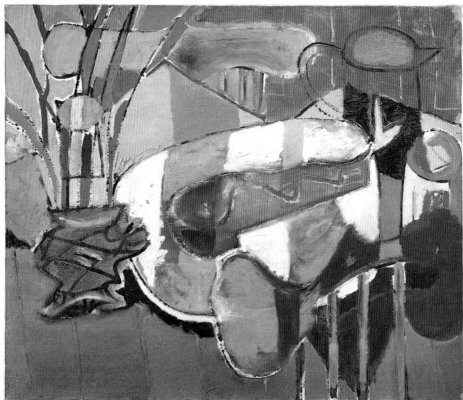

powerful personalities, which Gabo especially allied to great charm, but even in the 1940s Heron knew his own mind. He objected to the whole thrust of the intellectualised abstraction – Constructivism to give it a catch-all title – practised by Nicholson and Gabo. He wanted abstraction to be an organic, living thing. Yet Nicholson, despite the fact that Heron had published more than one adversarial review of his work, went out of his way to help Heron, and later cleared it with the trustees of his Porthmeor studio that Heron should inherit it when he himself left to live in Switzerland in 1958.

In England, the two painters to whom Heron felt most attracted were Ivon Hitchens, the painter of gentle abstracts based on the landscape of west Sussex, and the lushly opulent post-Fauve Matthew Smith, precisely because they both worked out of the French tradition. In 1948 Heron wrote a letter to Hitchens, evidently asking about the availability of colour reproductions of the older painter's work. Hitchens's reply lamented the lack of colour reproductions of his paintings – not enough interest in him as a painter, he remarked cursorily – but added that good black-and-white reproduction would be better than so-so colour work. And then Hitchens opened out the question of colour in painting: 'If our theories are correct there must be a great gulf fixed between ourselves and say Turner. What would happen to our space relations if on varnishing day we sploshed vermilion over some accurate venetian red? Yet don't you find the temptation to do just that to enjoy the "carpet" effect?'[4] It is clear that among the older contemporaries that Heron respected most (in 1955 he would write a book about Hitchens for the Penguin Modern Painters series) he was already regarded as one of the band of brothers for whom colour as the definer of space on the flat plane of the canvas was the essence of the art.

The wide intelligence and premeditation with which Heron approached his work in the 1940s and 1950s should not have been a surprise – he was quoted in the Tate retrospective catalogue of 1998 as saying, '…when I did finally have the show at the Redfern, in October 1947, it was full of French influences, *one after the other* [author's italics].' In the same publication, the novelist and critic A.S. Byatt characterised Heron's painting as 'a profoundly intelligent art, a thinking art as well as an expressive art'[5]; and she ended her vivid catalogue essay for his posthumous exhibition at the Waddington Galleries: 'He was an English visionary, but a thinking one.'[6] In 1943 Delia dropped in to watch him at work on *The Piano*, and was surprised at how deliberately he filled in an area at a time with colour, rather than attacking the surface as she had expected and covering the whole area with colour as Cézanne habitually did. Susanna Heron remembers her father, many years later, lecturing a group of art students at Kingston-upon-Thames, emphasising that they must resist the temptation to start splashing paint on to the empty canvas until what needed to be done came almost as a matter of instinct.[7] None of this is incompatible with Heron's other reiterated advice, that the hand should be

27

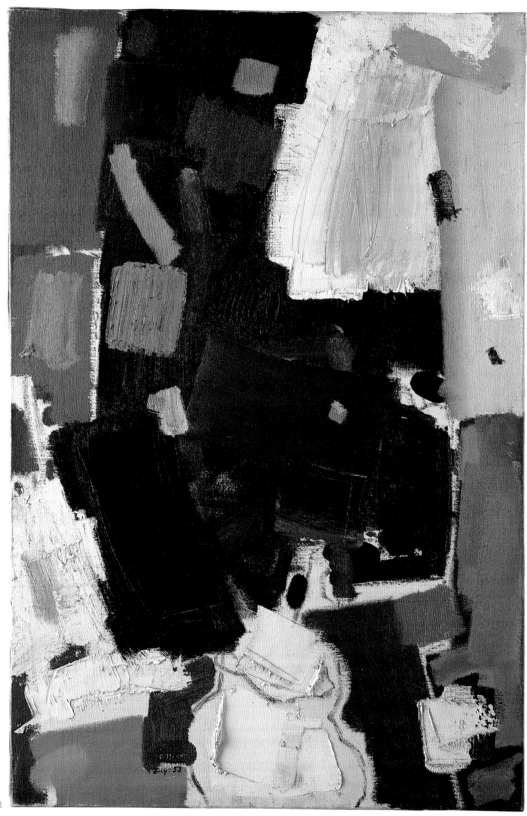

22
*Square Leaves
(Abstract): July 1952*
Oil on canvas
76.2 × 50.8
Collection of the
Artist's Family

23
Nicolas de Staël
Composition 1950
Oil on board
124.8 × 79.4
Tate, London

allowed at a key point to take over from the brain or the design on the canvas would be stillborn.

In some early works Heron had already pushed over the border into abstraction, for instance *Square Leaves (Abstract): July 1952* (fig.22) and *Abstract: Red and Black: August 1952*. He had painted both and a few others after being deeply impressed by a show of Nicolas de Staël's paintings (fig.23), with their thick, palette-knived texture, at the Matthiesen Gallery in New Bond Street, London, the same year. *Square Leaves (Abstract)* contains, just, recognisable objects, but together these paintings show the direction of Heron's thought at the time. There is no tentativeness here, but the notion that the word 'Abstract' should be incorporated into the titles suggests a reconnaissance of abstraction rather than a frontal attack.

In June 1952 Heron, reviewing an exhibition by Hitchens, expounded the virtues of 'the central tradition in Western painting' as opposed either to pure abstraction or to realism. The central tradition, Heron explained, consisted in the balance between the qualities of paint and the qualities of the subject matter of the painting. 'The point is: the stabbed arc of greeny-olive paint [in a Hitchens canvas] is the pine branch. You are not made conscious of an object (the pine branch) and at the same time left unconscious of the actual paint that evokes it: that would be the fallacy of realism, which aims at an illusionistic rendering of natural appearances. Nor, on the other hand, are you conscious of some paint on canvas, but not conscious of the pine branch: that would be the fallacy of "pure abstraction". Instead, you are conscious of the branch as paint. In such duality lies the central tradition I have mentioned.'[8]

Just so; but this duality was to prove troublesome. In 1955 Heron wrote:

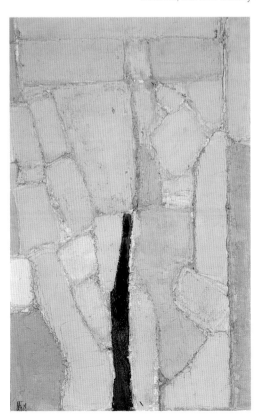

'Although I am convinced that it is the underlying abstraction in a painting which gives that painting its quality, its life and its truth – nevertheless, I believe one's abstraction may just as well add up to an image of a girl at a window as to an image of electronic energy.'[9] Not too much about the central tradition here, more a matter of the figurative element being merely a convenience. The notion of abstraction, pure if not simple, was crowding in on Heron. As for a girl at a window, she appeared in *Figure in Harbour Room (Orange & Grey): 1952–54* (fig.24), her raised Braque-like blue-grey arm hooked around the indeterminate shape of her blue-grey hair and enclosing the sort of orange space that Heron was to identify in his later abstracts as a harbour shape. The painting is of a room, a girl, a window. It is not an 'illusionistic rendering of natural appearances' nor is it a 'pure abstraction'; but despite Heron's reservations at the time, pure abstraction was on its way.

To a degree, this journey can also be traced in Heron's own writings. He had started his parallel career as an art critic in 1945 when he visited his parents in Welwyn Garden City and met Philip Mairet, the editor of *New English Weekly*, who was captivated by Heron's table talk and invited

him to write for him. His first piece was a review of a show by Ben Nicholson. He did not spare his illustrious new friend. 'For in those measured squares and circles,' he wrote, 'overlaid with a paint as smooth and innocent as ether, from which all hint of human furniture is emptied, all echo of familiar, long-loved forms removed – chairs or tables, eyes or roses, chimneys or the sea – we have the conclusion of a logic which will be found to be at a tangent to the mainstream of art.'

Instead, Heron argued, in seeking 'the forms which life alone conceals', the painter should look elsewhere than the ruler and compasses: 'Rather one sets one's face towards the incoherent, vast and vastly intricate anonymities of Nature: towards the faceless and baffling but rich-to-infinity fields of Nature herself – which exist for the painter's purpose, in whatever surrounds his physical frame by day, by night, in the moors of Celtic Cornwall and by the sea-sucked rocks, or in the lemon lamplight upon a stained and flaking city wall; in the lichen-covered stones of Zennor, or across the glittering surfaces of a Euston ABC's glass table.'[10] Heron was giving his first essay everything he had got, some of it, at a guess, borrowed from the lichen-covered prose of his neighbour in Cornwall, the critic Adrian Stokes; but in these words there is a strong prefiguring of the approach that would sustain Heron throughout well over half a century of painting. Finally he was to give up for good the notion that 'one's abstraction may just as well add up to an image of a girl at a window', but, even in the days when he disclaimed any subject matter other than the paint and the canvas, he would never become reconciled to the measured squares and circles of Nicholson and others; never accept, in other words, the predominantly conceptual.

Heron is said to have been a celebratory critic, and this is true. He wrote mostly about those things of which he could approve. Even in this first piece on Nicholson, he acknowledged the older artist's achievement, if in muted terms: 'It is clear … that he will be significant to the future historian of English painting.' He would, in the next few years, use his column in the New York magazine *Arts Digest* (later just *Arts*) to propagate the virtues of his friend William Scott and his friend Peter Lanyon, and to proselytise perceptively on behalf of the work of his friend Bryan Wynter. He would publish a piece called *Introducing Roger Hilton*, 'a painter I have long believed to be in the front rank'.[11] Scott and Lanyon never became wholly committed to wholly abstract art; Wynter and Hilton did; all of them took divergent paths from Heron. Yet despite the growing hard line of Heron's expressed views (see his most famous dogmatism: 'It is obvious that colour is now the *only* direction in which painting can travel'[12]) he found no difficulty in reconciling his own practice with his approval of other quite different kinds of painter. In any case, his dogmatic expression of views was often a form of shorthand. Late in life he was to remark, 'I would go around the world to see a good Matisse. I wouldn't cross the street for a Rothko.'[13] Without trying to soften the edges of Heron's acerbity, all this really meant was that for him Matisse was the greatest painter of the twentieth century and that Rothko, fine though he was, had, in Heron's view, ultimately misunderstood colour by deploying it for numinous, quasi-religious purposes inimical to the uses of painting.

Heron's dogma was usually more accommodating than it looked at first intimidating sight. Colour, in short, was the material of painting: 'the sensations of colour, which give the light', in Cézanne's phrase, are the first things people are aware of when they open their eyes.[14] In painting it is the bestower of

24
Figure in Harbour Room (Orange & Grey): 1952–54
Oil on canvas
91.4 × 45.8
Collection of the Artist's Family

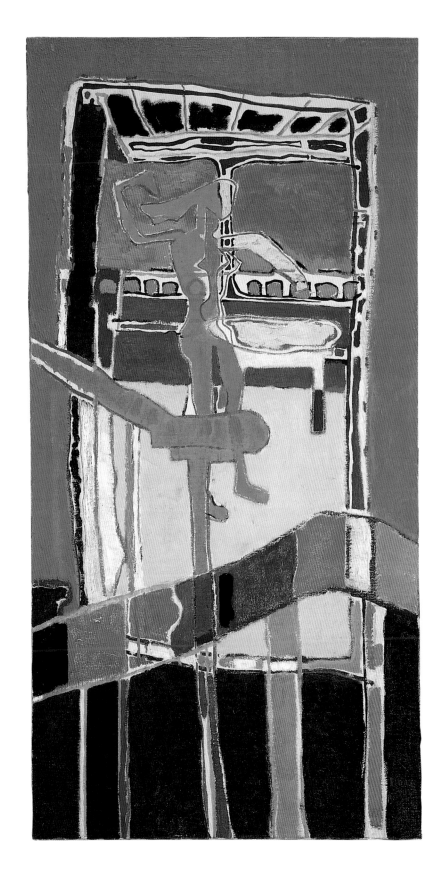

space. Brush two colours on to a white canvas, and one or the other colour will always appear to be in front. Manipulating colour on the two-dimensional picture plane is the artist's business, no more, in Heron's view, and no less. 'Colour is now the *only* direction…'

But in the 1940s and 1950s there remained that girl in a window, boats in a harbour, the church at Zennor. Bonnard had never discarded either the woman in the bathtub or the compotier of fruit, but the true subject of his paintings was abstract space – recession in depth and the lateral organisation of space. The subject might be the same over and over; the preoccupation remained the same yet contained the infinite variety of Bonnard's invention. One of the most telling passages in Heron's critical writing in its relationship to his own growing practice as a painter is in his early essay, *Pierre Bonnard and Abstraction*. In it, he compares Renoir and Bonnard. Renoir, he says, 'developed the form of the various objects in his composition more or less separately: that is, sculpturally. The beauty of form of a head, a breast or an arm, or of tree trunks, or fruit, in a Renoir picture, is something we can contemplate in ignorance of the rest of the canvas: each object has its own self-centred perfection of form – which is a sculptural form.' To the contrary, 'the form of objects in a picture by Bonnard hardly exists in isolation from the total configuration… Bonnard's forms have an apparent flatness: the masses of his forms seem flattened so as to display the largest area or plane to the spectator. But this flattening is somehow itself the very agent of spatial realisation…'

Heron wrote this essay in February 1947 to celebrate the life of Bonnard, having received news of his death. He sent it to the English periodical *Horizon*, the intellectual's knapsack bible of the wartime years, when most of the favoured modes in English art were post-Romantic and figurative: the spiky, anthropomorphic forms of Graham Sutherland, the illustrative romanticism of John Minton, John Piper's thunder and lightning overtures, the dual post-Cubist trapeze act of Robert Colquhoun and Robert MacBryde, Keith Vaughan's khaki but unclad hymns to male beauty, Paul Nash's suburban Surrealism. *Horizon* sent it straight back. Had Heron been a reader (Delia was), he would have known that its co-founder and editor, Cyril Connolly, had already at the end of the war announced the death of European culture: 'The great marquee of European civilisation in whose yellow light we all grew up, and read or loved or travelled has fallen down … never have occupying armies had less use for the countries they invest. The gulf between civilisations has grown too wide.'[15]

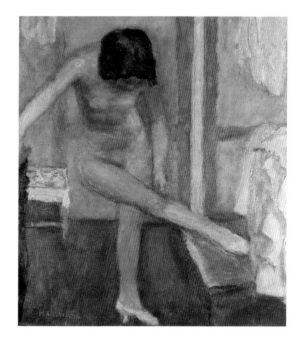

The rejection slip from *Horizon* meant a postponement of the Bonnard article's publication until 1955, when it appeared in Heron's first book of critical writings, *The Changing Forms of Art*.[16]

If *Horizon* rejected the piece on Bonnard, the *New Statesman and Nation* was becoming increasingly uneasy by the late 1940s about its fractious critic,

who bombarded them with letters of abuse about their copy editing and who would not comply with the request of T.C. Worsley, a theatre critic and editor of the arts and entertainment pages, that he should moderate his enthusiasm for propagating the glad news of colour in space. V.S. Pritchett, who as literary editor was in charge of the totality of cultural coverage, intervened to help Worsley at one point by giving Heron a few pointers on clear writing: working in the active voice rather than the passive and not letting subjunctive clauses run away with him. He concluded: 'Well, that sermon in return for yours. We are putting your Grant and the shorter piece in this week and now sit back waiting eagerly for your next salvo.'[17]

But after a saga of agonised discussions and exchanges of letters, Worsley steeled himself to write a 'Dear John' letter to Heron: 'I'm rather afraid the time has come when I shall have to ask you, with what regret you know, to give up, at least temporarily, the regular art critic's place. I needn't after our talks go into all the reasons again. But in general the feeling is that readers must have at least a *rest* from wrestling with new problems of space!'[18] Heron replied, in an otherwise sweet-tempered letter, that he agreed that it was time to go 'because the strain of bending my deepest desires and instincts to the requirements of the NS and N (as you see them) has often been almost unbearable!'[19]

25
Pierre Bonnard
Nude Bending Down
1923
Oil on canvas
57.1 × 52.7
Tate, London

Heron's replacement, Basil Taylor, developed into one of the finest post-war critics, as Heron acknowledged; but he was never, like Heron, in a position to bring news direct from the front. Several letters from other artists in the 1940s and 1950s testify to this. Victor Pasmore, Reg Butler, William Coldstream and Roy de Maistre all wrote to Heron to say that it was good to read the criticisms of a man who understood the business at first hand; Braque wrote, after requesting and receiving a copy of *The Changing Forms of Art*, to say that Heron had perceptions of which no ordinary critic was capable; Pierre Soulages wrote to say: 'After seeing these photographs [of Heron's work] I understand better the interest that you have in space and the importance that you give it in your thinking about painting – I agree with you and in what you write about my painting…'; Henry Moore wrote from his home at Much Hadham: 'Naturally I like the article [in the *New English Weekly*] very much indeed – but not only because what you say about my work pleases me, but also because it is criticism that could only come from someone who has practised himself – and responded to the work in the way it was done.'[20]

On hearing of Heron's departure from the *New Statesman*, his younger brother, Dom Benedict, wrote (to Pat, from Mike) from the religious institution, the Vita et Pax Studiecentrum, in Louvain, Belgium. He begins by congratulating Patrick on the success of his third exhibition at the Redfern Gallery, which opened in April 1950, and adds: 'I was not at all sorry to hear that the *New Statesman* job is finished; one cannot go on doing such a job for too long.' That's an unexceptional and wholly sensible family concern. Rather more to the point is the sensitive passage that follows:

Recently I have often thought that many people who would say that their lives were empty of prayer and religious faith are really living just as prayerful and faith-full lives as practising christians. After all, your meditating and dreaming is probably prayer, and the very fact that you continue to paint is an act of Faith in Providence that Providence will somehow look after things. We are all living the same spiritual life, whether we recognise the fact or not; only it sometimes helps people to live it more successfully if they know what they are doing.[21]

This shows remarkable and sympathetic insight about the challenges of being a creative artist, which Patrick, twenty years later, was to write about in

painterly terms when he described the thrilling and dangerous necessity of allowing the arm to take over from the brain, or the suspense of not knowing how a fourteen-foot oil painting, being accomplished inch by inch with tiny Japanese watercolour brushes, would turn out until the conjunction of one field of colour with another was achieved.

Heron continued to make occasional forays into journals like the *Listener*, and more frequently from 1955 as London correspondent for *Arts*, but these assignments were less regular. When he foreswore these outlets too in 1958, he wrote rarely, and then just occasional catalogue introductions or articles about what he perceived as government threats to art education or on environmental issues that interested him closely. Without a public platform, he would occasionally explode into private irascibility with those who had his best interests at heart. Herbert Read failed to include a reproduction of any Heron painting in his book *Art Since 1945*, first published in 1958, and Heron wrote in December of that year to complain, 'I have never felt so bitterly let down.'[22] Read replied with an assumption of good humour: 'What a vain irascible crowd you artists are. How mild and stoical in comparison the poets! Do I complain when Lord David Cecil leaves me out of an anthology of contemporary verse?'[23] This cut no ice with Heron who wrote a second time and said: 'I can only conclude, Herbert, that my main interest for you, all these years, has been as an invaluable pilot where the painters of my own generation were concerned. The pilot is now dropped.'[24] But between them, Read's patience and Heron's sweetness healed the breach.

In 1953, Heron had organised an exhibition for the Hanover Gallery, London, for which he settled on the title *Space in Colour*. Ten artists took part. They were Alan Davie, Terry Frost, Roger Hilton, Ivon Hitchens, William Johnstone, Peter Lanyon, Victor Pasmore, William Scott, Keith Vaughan, and Heron himself. The common factor, as the title suggests, was supposed to be that all the artists approached their work in the Heron-approved way, by creating the sense of space through the use of colour. Vaughan, particularly, felt uneasy about this, and Lanyon felt he was being misrepresented.[25] But the catalogue introduction is as close as Heron comes to a manifesto on behalf of his own approach, if manifestos can be empirical in tone rather than declamatory.

In painting, space and form are not actual, as they are in sculpture, but illusory. Painting, indeed, is essentially an art of illusion; and 'pictorial science' is simply that accumulated knowledge which enables the painter to control this illusion, the illusion of forms in space. But the secret of good painting – of whatever age or school, I am tempted to say – lies in its adjustment of an inescapable dualism: on the one hand there is the illusion, indeed the *sensation*, of depth; and on the other there is the physical reality of the flat picture surface. Good painting creates an experience which *contains* both.[26]

Heron's dualism had evolved again, and now the girl at a window was nowhere to be seen. Heron was still painting beautiful French-inflected interiors and still lifes, still in Holland Park. But then two things happened. In 1955, Mark Arnold-Forster sold him Eagles Nest. And in January 1956, *Modern Art in the United States* at the Tate became the biggest show in town.

3
The Biggest Show in Town

Cornwall was Patrick Heron's Xanadu, Eagles Nest its stately pleasure dome. Since the family had been forced to leave Cornwall when Patrick was only nine years old, he had repeatedly revisited St Ives, while he was at the Slade, while he was a wartime labourer, and then, through the good offices of Bernard Leach, for the last months of the war. Afterwards, he and his own young family came in the summers to a rented house on St Andrew's Street, St Ives, looking across the harbour at the lighthouses on Smeaton's Pier, the view that was the basis for *Harbour Window with Two Figures, St Ives: 1950*.

J.M.W. Turner had visited St Ives, and all through the twentieth century artists came to this corner of west Penwith. The view looking down the precipitous slopes from the massive garden rocks around Eagles Nest is towards a tiny group of cottages and farm buildings in the parish of Zennor called Higher Tregerthen. In 1916 D.H. Lawrence came to live at Tregerthen with his wife Frieda. 'When I looked down at Zennor, I knew it was the Promised Land, and that a new heaven and a new earth would take place,' he wrote. And beyond Tregerthen is 'the infinite Atlantic, all peacock-mingled colours'.[1] Heron's friend Bryan Wynter lived in the Carn, a converted crofter's cottage among the bronze-age fields above Eagles Nest.

Eagles Nest itself may have an ancient core, but it is now a slate-rooted multi-gabled late Victorian house. Approached from St Ives along a winding road, not much more than a lane, and silhouetted in the dark with a single window lighted, it has the forbidding presence of a building in a Gothick romance. When the wind rose and howled around the house, which was often, the Heron family's half-joke was, 'Oh no, not Wuthering Heights again.'[2] Virginia Woolf, a friend of Ka Arnold-Foster (née Cox), stayed there in the 1920s while Ka's husband, Will Arnold-Forster, was creating the garden that became one of the finest in England, a haven for plants from the East, from Latin America, and from Australasia, pines and rare camelias, rhododendrons and azaleas forced out of the peat and gorse between the huge rocks surrounding the house. Woolf's diary entry for 13 July 1920 includes: 'Ka has taken the Eagle's [sic] Nest … I wish it were mine.'[3] Even in bitter December, white Chinese camellias still blossom and fill vases in the granite-grey house, painted white inside by Heron, his canvases unframed, his gouaches on big mounts in white frames.

It was April 1956 when the Heron family moved in – now four: Susanna had been born in September 1949. A month earlier *Arts* had published Patrick's review of *Modern Art in the United States*. The gung-ho room of Abstract Expressionists in the Tate show had created a sensation among younger English artists, including both Heron and Bryan Wynter.[4] The confidence of these canvases by Jackson Pollock, Robert Motherwell, Mark Rothko, Clyfford

Still, Willem de Kooning and Franz Kline – confidence of attack, confidence to reject imagery beyond the painted picture surface in itself, confidence of scale – hit the artistic community in London like a tidal wave up the Thames. 'I was instantly elated by the size, originality, economy and inventive daring of many of the paintings,' Heron wrote.

Then came the first 'but', and it was a 'but' that would never go away for Heron: 'There is always, however, a lack of resonance in their colour.' Neither de Kooning ('all ladylike, gossamer, pastel tints!') nor Pollock fully understood the science of colour, Heron argued. And Pollock, though by now 'one of the most influential painters living', failed at a crucial level: 'from a distance, this Pollock painting seems to be a great patch of fungus, only three inches in depth, there on the wall. This, I think, is due to the total absence of any strong planes, particularly planes parallel to the canvas itself – and I believe that such planes are always the prime agent of pictorial space.' Heron rated Motherwell's *Granada* the finest painting in the show (it had, he said, for him 'twenty times the spatial punch of a Pollock or a de Kooning'); and he judged Rothko to be the more important explorer of colour.[5]

It seems entirely likely that an underlying reason for Heron's antipathy to Pollock's work was that he sensed that it grew out of Surrealism (as, actually, did the work of most of the other artists), a movement which Heron thought literary and irrelevant. Pollock himself said it was inevitable that if one painted subconsciously the human figure would find a way on to the canvas, and it is well known that many of his abstracts, even his classic 'drip' paintings, contain subterranean figures obliterated by the criss-cross of gestural marks.[6] Heron, to the contrary, did not paint from within; he responded, like the French masters, to visual stimuli.

Heron's reservations about the Abstract Expressionists, voiced in the same article as his enthusiasm, were absolutely in line with his own practice. He was European, shaped by the formalist criticism of Roger Fry and the painting of the great Fauves and Cubists, and on the edge of his own breakthrough into pure abstraction: in hindsight it is impossible that he should have readily responded to 'the power and flux and surge and energy of nature, of the human body in relationship to it', as John Golding has written persuasively of Pollock.[7] Heron's art was reflective, not in any sense 'action painting', to use the contentious label applied by the critic Harold Rosenberg to Abstract Expressionism.

William Scott, Alan Davie and Peter Lanyon had already seen Abstract Expressionist painting in the early 1950s, and Scott, who had visited Pollock and de Kooning on Long Island, New York, had reported back to Heron, who showed immediate interest. To the extent that most other English painters had known the work of the New York school, it was only through small reproductions. Heron's initial sense of elation in 1956 swept through the rest of the younger artistic community as well – bliss was it in that dawn to be alive. On the grounds of the expense of materials alone, the generation of post-war English painters would have been nervous of working on this scale or with this revolutionary sense of abandon, and very few had felt able to sacrifice the haven of some sort of reference to natural forms. Now, and quite suddenly, the galleries of Cork Street in London were filled with big abstractions, good, bad, or just indifferent, inspired by Abstract Expressionism.

Heron never at any point acknowledged much of a debt to the influence of the American show beyond that first fine rush of elation that came with the realisation that it was entirely possible to break the grip of Paris. The Americans

26
Autumn Garden: 1956
Oil on canvas
182.9 × 91.5
Collection of the
Artist's Family

36

had done it with enormous athleticism. For them it was in a sense easier. In Wyoming and North Dakota, Paris might just as well have been on Mars.[8] Pollock and Still were young guns who had ridden out of the West; de Kooning was an illegal immigrant who had fought his way up from house painting; Rothko was an émigré from Russia who had thought his way to Yale to read philosophy.

The influences on Heron remained more complex than these. There was still the French school from Cézanne to Matisse – and Heron's critical essays, which were a form of thinking aloud, showed how close he was in the early 1950s to realising the logic of the move from these sources into total abstraction. The two abstracts painted in 1952 draw on his admiration for Nicolas de Staël, with his 'fat little squares or oblongs of thick, brushed paint'.[9] Heron's paintings were good, but he did later describe his skirmish with abstraction at that point as a false move – they seem too dependent on direct influence, which was never Heron's way; and they were thickly smeared with the palette knife, a method normally inimical to him.

Three years later, the Herons bought Eagles Nest, and though the house needed refurbishing, they spent part of 1955 in St Ives: it would have been impossible to keep Patrick away from their new house at Zennor during that period.[10] So by the time the Americans hit the Tate in January 1956, the thrust of his own thinking, the colours of the garden, the profusion of shapes, and the light thrown back from the Atlantic had all worked their alchemy: west Penwith is so narrow that it could as justly be described as a spit of land as a peninsula. Heron described the ocean surrounding Eagles Nest as a gigantic mirror, 'brilliantly silver, and reflecting white light upwards. To have the rocks and the bushes illuminated from below, from a glittering reflector which is over 600 feet beneath one, and many miles wide – is a special experience.'[11]

In 1955 he painted *Girl in Harbour Room* with its Braque-like framework, but with the significant development that colour is dabbed on in streaks and blobs that are almost in counterpoint to the linear structure. In *Winter Harbour: 1955*, painted soon after, Heron very nearly dispensed with the mesh altogether, and the jostling dabs convey more of the sense of a busy harbour than any dim figurative reference remaining. He confessed that at this point he was anxious to lose the 'umbrella' of the great masters of Paris. If he owed anything stylistic to any American, it was to Sam Francis, but Francis was an honorary Frenchman. He had found, or founded, his style in Paris as one of the group of Tachiste painters – Hans Hartung, Alfred Manessier and Pierre Soulages among others – which was gestural painting of a softer kind than Abstract Expressionism, but which ran parallel to it. The Tachistes had little of the bravura of the New Yorkers, but were a deal more subtle. Heron admired Francis in particular, and befriended him on a visit to his studio in Paris. 'The colours, and the rhythmic divisions of a canvas's surfaces that he found in France underpinned every single abstract statement, every configuration of design, that he ever made throughout the rest of his life,' Heron wrote on Francis's death in 1994.[12]

So by the end of 1955, and quite by design, Heron was moving away from figurative subject matter. From January 1956, the Braque-like linear mesh dropped away and Heron was left with a surface covered with colour strokes. Later he would say that this was the point at which he at last ceased to feel the influence of Braque, though he never ceased in admiration. At the moment when he was moving into clear water away from Braque, he wrote poignantly of

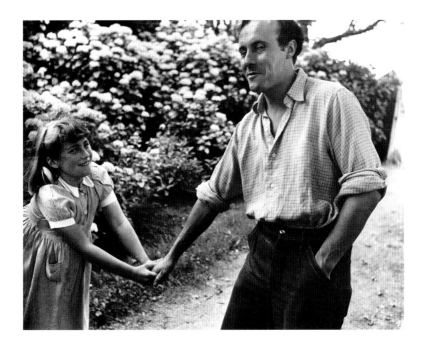

the importance of this great pioneer to all painters who came after him, whether they knew it or not. He describes the late landscapes and the way in which they and certain other paintings of the 1940s and 1950s prefigured Tachisme and the abstraction of de Staël: 'So I am saying: With a painter as great as Braque it is meaningless for younger painters to say either "We accept him" or "We reject him." Modern art has not flowed round a figure of this size: it has flowed through him. We may have the *feeling* that we reject: but the fact is, we are only who we are and where we are because, in large measure, Braque is who he is where he is. Our present hopes and researches would not exist if his own had not preceded them.'[13]

After Braque, Heron would have liked to have shaken off the influence, too, of Bonnard and Matisse, but admitted that in everything he did from 1955 onwards, he still sensed them looking over his shoulder. The paintings he made at Eagles Nest in 1956 amounted to abstraction fully embraced. There were the vertical paintings, including *White Vertical: May 1956 (Black)* (fig.28), and then between May and August he painted a group of five canvases clearly full of the sense of the light and colour of west Penwith high above Wicca Cove. They were mistily opalescent or aerial and bright, and the light and colour were clearly inspired by the garden at Eagles Nest, now being taken in hand by Delia. He called his work in the exhibition at the Redfern Gallery in June *Tachiste Garden Paintings*.

The phrase may not have helped the cause. For Heron, the paintings were analogous to the experience of a garden. The critics had been primed by Tachisme and Abstract Expressionism to accept what Heron had called 'creative emptiness', but (and, after all, not surprisingly) the reference to 'garden' threw them off the scent. They spotted not analogy, but illustration. The critic John Berger in particular compared the show unfavourably to late Monet; but late Monet, Heron had already argued (and how many more times would he have to press the point?), was still representational: 'abstract *content* is missing in the lily ponds'.[14] Heron was attempting to create visual sensations

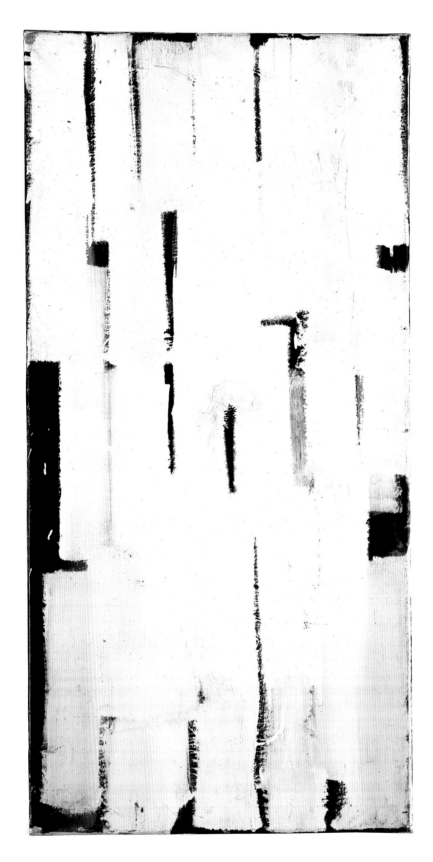

through the medium of paint alone. The gap might seem small, but it was *his* gap: it was the gap he had been trying to bridge since 1945. The whole enterprise had been fraught. His published criticism was not always consistent, but it was consistently a barometer to his thought processes about his own art.

On 7 February 1956, as Heron was pushing out in this new direction, Herbert Read wrote to him. At this point Read was the heavyweight of art politics, never mind criticism, who always championed abstract art. During Heron's spat with John Berger, he had written: 'I enjoyed the Berger debate, but he is so impossibly illogical and one loses patience with him. It is like a bad cocktail – too much vermouth in the gin', a simile that would only have confirmed Berger in his own views about the art establishment.[15] Now Read was putting together a *Critic's Choice* show for Tooths, one of the most distinguished galleries in London, and he wrote to Heron inviting his participation: 'I am determined to take the opportunity to make an abstract demonstration, which is, after all, my personal taste and inclination … I want to make a very united show, and no compromises. I don't mean an academic abstractionism, as the names of [William] Scott and [Alan] Davie will indicate. How abstract have you become?'[16] The exhibition went on in Bruton Street in November, and contained three new Heron abstracts.

Heron's new way of filling canvases from edge to edge with evenly stressed touches of effulgent colour lasted until 1957, but he must always have been aware that they looked too much like Tachisme, the style he felt had rapidly become the new academicism. He began to feint towards his next direction of attack by stretching the dabs of colour into stripes until, quite suddenly, the stripes began to touch bottom and he had the first of the so-called stripe paintings. Nothing but stripes of colour, either top to bottom or side to side; the stripes occasionally widened into blocks. The first fully achieved, unremittingly extreme canvas was *Vertical Light: March 1957* (fig.29). It is not huge (a little under two feet deep by just over four feet wide), but then Heron was painting in his own house: most of the really big paintings would come when he moved into his Porthmeor studio the following year.[17] It consists of a few stripes of purple, cadmium, deep blue, a dark green, and an almost bituminous brown singing against predominantly white and tonally-varied lemon stripes. Its simplicity and economy, wrote the painter Alan Gouk much later, suggested that Heron had finally found his own subject: 'Hence the perfect fitting of a sensuous at-homeness with the simplest uses of the means, and an open responsiveness to the morning beneficence which each day's sun throws upon experience, and a raising of feeling to the level of it.'[18]

More pragmatically, Heron said that it felt as though he was making the most radical paintings in the world. For him, it must have been something like the experience of Matisse and Derain in those few mad weeks in Collioure fifty-two years before, when, with mixed trepidation and elation, the two men binned the whole Renaissance tradition and divisionism with it, and Derain wrote to Matisse's son-in-law: 'Colours became sticks of dynamite. They were primed to discharge light.'[19]

Those critics who had rejected the notion that decorative art can be great art, art of the highest import, need only be pointed at those revolutionary paintings by Matisse and Derain, or at these revolutionary paintings by Heron. Towards the end of the next decade Alan Bowness wrote: 'I can think of few more disconcerting pictures shown in England in the last twenty years than Patrick Heron's striped paintings of 1957.'[20] Sometimes Heron mixed stripes

28
*White Vertical: May
1956 (Black)*
Oil on canvas
91.4 × 45.8
Collection of the
Artist's Family

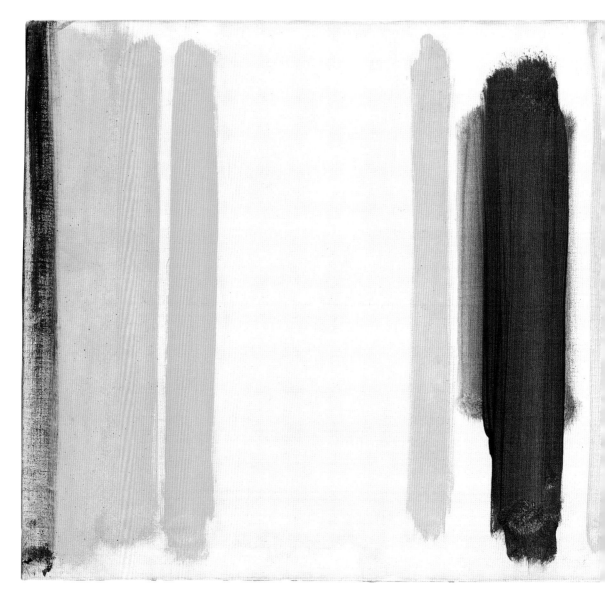

29
Vertical Light: March
1957
Oil on canvas
55.9 × 121.9
Collection of the
Artist's Family

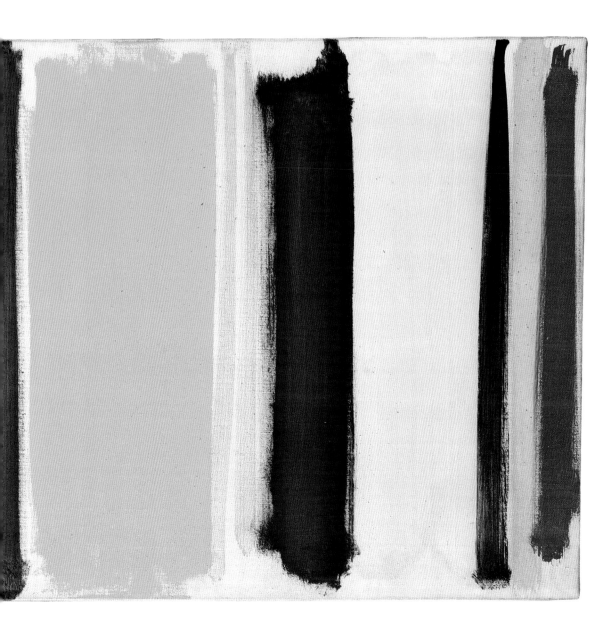

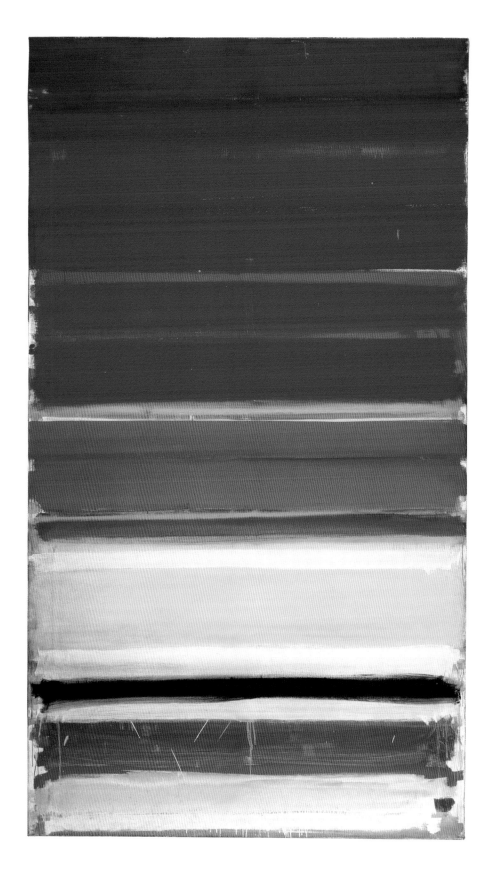

44

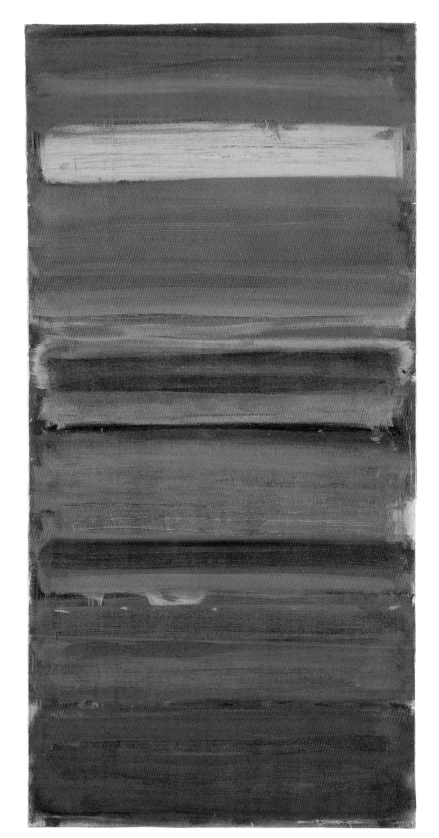

30
Horizontal Stripe
Painting: November
1957–January 1958
Oil on canvas
274.3 × 152.4
Tate, London

31
Lux Eterna: May–
June 1958
Oil on canvas
182.9 × 91.4
Private Collection

with blocks of colour and produced a prototype for his paintings of the next few years; like most prototypes, they were a trifle ungainly. The last of the stripe paintings, *Lux Eterna: May–June 1958* (fig.31), far from ungainly, was all earth colours with gleams of yellow and cadmium. The title, Heron later said, was bogus, chosen merely because he wanted it to be included in a Contemporary Art Society exhibition at the Tate called *The Religious Theme*. He painted stripes in colours from yellow and orange to indigo and violet. People insisted on seeing rainbows, or horizons. Heron might have expected the public to be slower on the uptake, but he was downcast. These paintings were abstract (though, again, the word 'horizon' had been used in some titles). There was no point of reference to the visible world. The subject of the paintings was the painting itself. 'Looking is more interesting than doing anything else, ever, as a matter of fact,' Heron said, and looking at paintings, looking at colour, looking at texture, looking at paintings of which the only subject was colour, was enough. No meaning, no subtext, no symbolism, just colour and shape.[21]

The first stripe painting to be exhibited to the public was *Horizontals: March 1957*, shown in a group exhibition in April 1957 at the Redfern Gallery. Delia had proposed the title *Metavisual* for the exhibition – her coinage, intended, presumably, to denote a seismic shift in perception from figurative to an abstraction in which the pictorial values lay in the use of paint rather than in subject matter. Rex Nan Kivell, the gallery's director, accepted the word but insisted on broadening it to *Metavisual Tachiste Abstract: Painting in England Today*. Tachiste had become a catch-all label for a trend that had become as hot as the latest fashion and quite as quickly *démodé*. The show was a spring hotchpotch containing the work of twenty-nine artists, and Heron's stripes attracted very little comment one way or the other, hidden as they were among the other work. But Herbert Read wrote another supportive letter to Heron saying: 'The Redfern show is very impressive. I thought your painting much advanced from the last show. Delia is to be congratulated on *Metavisual* – it is certainly better than Tachiste, but Paris usually decides these things.'[22] He was right: but the days of Parisian dominion were numbered.

In 1958 Heron had his seventh one-man show at the Redfern, and for the first time his career shipped water. The enlightened art-book publisher, Peter Gregory of Lund Humphries, had backed Heron's latest career move by commissioning *Horizontal Stripe Painting: November 1957–January 1958* (fig.30) for a particular slot in his newly designed London offices. But when the Redfern exhibition opened in February the critics were not amused, and nor was the gallery's director, Nan Kivell. He wrote to Heron complaining that he was just beginning to find a market for his still lifes and now Patrick had to hit him with this. Most artists have to put up with gallery owners who would like them to stick to the latest selling line; now Nan Kivell added a refinement. After three days, with the sales, or lack of them, a disaster, he switched the lights off and closed the show for a week while he had the gallery redecorated. When the decorator had finished, Heron found tiny splashes of white paint like birdlime on his canvases.

It was not the vote of confidence he needed. And on top of this, those newspaper and magazine critics who had gained admission were baffled. The anonymous *Times* critic and Neville Wallis of the *Observer* both thought the paintings might have something to do with the science of colour. John Russell of the *Sunday Times* pronounced that they were poised 'on the edge of the absurd'. Even the painter and critic – and friend of Heron – Andrew Forge shot

comprehensively wide of the target. 'One misses the sense of a particular statement, an unhesitating will to make the particular picture expressive in a certain way,' he wrote, though the stripes were vastly varied in colour and effect, some brushed in with single strokes of pigment, thinned with turpentine, in as little as half an hour, others worked in many layers with scrapings and repaintings over weeks.[23] Later that year Heron contributed an essay to *Architecture and Building* to mark the Lund Humphries painting, in which he said: 'space in colour is the *subject* of my painting today to the exclusion of everything else' – a commitment he was to repeat in different words in lectures and catalogue introductions and articles for the rest of his life.[24] It might have helped if this piece had been published before the exhibition at the Redfern; but probably not.

Heron was at Eagles Nest when the show closed. Bryan Wynter, who had written a good-luck message from Cornwall before Heron's first Redfern opening in 1947 ('Hope all goes well and you have lots of nice red spots'[25]) was in London this time. He reacted with scandalised solidarity, cancelling his own next one-man show at the Redfern Gallery, walking across Cork Street, and joining the new gallery on the block, Waddington. Heron later called the Redfern fiasco a public insult; meanwhile, he followed Wynter to the Waddington Galleries.

What is easily forgotten in the folk memory of these events is that, alongside the stripe paintings that had so perplexed and antagonised the critics, Heron had exhibited other abstracts which had been painted over the previous year. In these he pushed Bonnard's mesh-like composition to its logical conclusion: in a sense he reconstituted Bonnard's paintings as harmonious abstract entities in which the separate elements of Bonnard's compositions were all part of a single image. He had written of Bonnard's work: 'There is an extraordinarily wide distribution of accent and pictorial stress … interest is as intense half an inch from the picture's edge as it is at the centre. Usually the edge of the canvas slices off half, or even four fifths! of some object at which our eyes have arrived with the greatest anticipation. Nevertheless, there is never any sense of arbitrariness; or of the composition being a mere slice of whatever was to be seen from where the painter was standing…'[26]

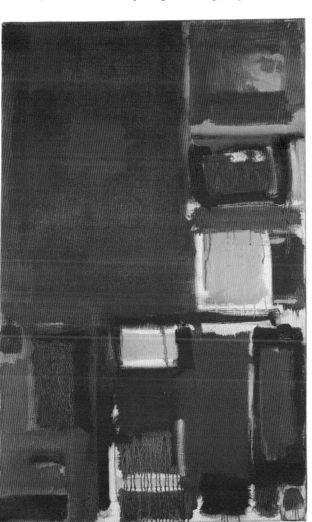

32
Yellow and Violet Squares in Red: February 1958
Oil on canvas
121.9 × 76.2
Collection of the Artist's Family

This might be a description of Heron's own work both in the late 1950s and for the rest of his life. *Yellow and Violet Squares in Red: February 1958* (fig.32), still wet when the exhibition was hung, is just what it says; but – and this is absolutely fundamental – the red is not a ground colour, it is just another colour element. There is no conceivable reference to nature, no horizon, no sunset. 'Today, the painting itself *is* the image,' he wrote in May 1958 in his review of the E.J. Power collection of American Abstract Expressionists and European abstract painters at the Institute of Contemporary Arts in London.

Straightforwardly, Heron was maintaining the principle of his stripe paintings, but, in a later phrase, 'recomplicating the surface'. The stripe paintings and these were not mutually exclusive: they were, in fact, done contemporaneously. But after *Lux Eterna*, completed in June 1958, he stopped painting stripes. The point at which he had arrived, inspired by that first sighting of the plumage of Abstract Expressionism at the Tate, was that basic stripes painted side by side on a canvas constituted the sole image, a basic architecture. This was his *reductio ad absurdum*, though not in the sense meant by the *Sunday Times* critic John Russell. As Heron pointed out in the E.J. Power review, even in the work of a European abstract painter such as Soulages the image survives: 'White equals space; black equals solid form.'[27] But Pollock's meshes of paint dripped from the can abolished the image contained within the composition and substituted the whole surface as a single image. Nevertheless, the general thrust of this piece was that the Americans were over here, over-hyped, and over-exposed. He had taken what he needed from them and now their defects weighed with him more heavily than their virtues; but he once again conceded that the New York painters had wrought a revolution: 'it was the Americans … who finally insisted, with a vehemence that has since converted almost everyone everywhere, that the total painting itself is the only image involved in a painting … Anyone who cannot accept that has not begun to understand the art of the present moment.'

He once more rated Rothko more highly than the others, but expressed again his doubts about Rothko's use of colour. Rothko himself claimed that his misty blocks of muted colour were not abstract, that, in fact, he was a realist painter; and this is so in the sense that he wished to invest his work with a deeper significance (Lawrence Alloway called his painting 'a Buddhist's television set'). Ten years after the ICA article by Heron, the critic Robert Hughes was to write: 'Whether or not you share Heron's conviction that the *only* direction left for painting to explore is that of colour, it is, I think, evident that the diffuse, omnidirectional colour of Rothko and the "field" painters has very little left to offer.'[28] Did Rothko himself wonder whether his paintings would bear the weight of subliminal meaning he put on them? He wanted his paintings to be invested with the solemnity of icons, but if he was an icon painter, he was the Andrei Rublev of high capitalism. In 1970 he killed himself, and on the day that Rothko's body was discovered, E.J. Power wrote Heron a distraught letter with one highly lucid phrase: 'It doesn't pay to make American artists rich,' he wrote, 'they end up having nothing to do.'[29]

Apart from his Rothkos, Power owned paintings by Pollock, Kline, Still and de Kooning, but also by two Europeans, Dubuffet and Antonio Tapies. Heron's review now addressed the work of Dubuffet and once again he was forced to acknowledge the power of the American achievement – a critical insight that tended to be forgotten in later years after he had embarked on a long campaign against the distortion of art history by American marketing: 'The Dubuffet is

almost unserious in comparison with the American paintings here, although it is "better painted" than any except the Rothkos.'

He followed this in the same year by taking what he termed a vow of silence as a writer on art, which meant resigning his position with *Arts*. The criticism he had written was rarely balanced by sympathetic criticism of his own work by other critics, and he probably had not enjoyed critics suggesting that his painting was in some way an illustration of his critical theories – when they weren't perceived as investigations into the science of colour, that is. Clearly, too, he was increasingly out of sympathy with the New York school, whose influence was spreading. But you would have had to follow Matisse's prescription for artists quite literally and cut Heron's tongue out of his head to stop him voicing his opinion on art and on the politics of art. And, as a matter of fact, on most other things. His daughter Susanna believed that he needed to engage in controversy of all sorts to clear his mind for the next bout of painting.[30]

Heron's book *The Changing Forms of Art* had been published in 1955 and had established his reputation; to the post-Second World War generation of artists, he was what Roger Fry had been after the First World War. In fact, when the idea of the book was still in embryo, the poet and critic Geoffrey Grigson had written to Heron on behalf of the publishers: 'Physically, the shape might be something like the shape of Fry's *Vision and Design*. But obviously you could mix art of all times with merely temporal modernity as Fry did in his book.'[31] This suited Heron well, and *The Changing Forms of Art* became prescribed reading in art colleges. But now it was time to go. In 1958 Herbert Read wrote to tell him: 'Your tactical mistake was to write so intelligently about painting … you may in time live down your intellectual reputation (on condition that you henceforth refrain from emitting anything but vacuous aphorisms), but meanwhile you must rely on the faith which you have in yourself and your destiny.'[32]

That was no problem. Heron himself said merely that he had given up writing criticism because he needed total commitment to painting. He told Read: 'I only want to go on creating my images of atmospheric colour – and that's what I'm doing – shall do – even if it means turning this place into a boarding house temporarily.'[33] It didn't quite come to that, but for a period before support came through strongly from the Waddington Galleries, he and Delia did take paying guests who received lessons in painting from Patrick.[34]

In May 1959 Heron showed a dozen paintings at the Waddington which were as abstract as the stripe paintings, but not as basic. He was painting either discs or lozenges floating against a larger field of colour. Even the stripe paintings had been attributed to the influence of Rothko by critics who had as yet grasped neither what Rothko nor Heron were about. But now the time had come when never again would a painting by Heron be mistaken for a painting by any other artist; never again would the influence of another painter be thought to have pushed Heron in a particular direction. The elemental statement of his own stripe paintings had convinced him 'that colour is now the *only* direction in which painting can travel. Painting has still a continent left to explore, in the direction of colour (and in no other direction).'[35] Although this was a show shared with his friends Terry Frost, Roger Hilton and Bryan Wynter, he was on his own.

4
Rembrandt's Mother's Nose

By the late 1950s Patrick Heron was making abstract pictures with no reference to nature; but nature inserted horizons or rainbows. And now that he was recomplicating the surface, people, friends, saw in his canvases the formations of the rocks thrusting their way through the earth of the granite moors above Eagles Nest.

Heron repudiated this. 'You would never see that rock like that if you hadn't seen these shapes on this canvas,' he says he told one imprudent visitor. In what reads like the edge of exasperation, he added: 'If I were Mr Seurat, not Mr Heron, you would be saying, "My goodness, look at all these separated blobs of violet and green all over the bloody sky."'[1] The truth, he knew, was more subtle, more interactive. Once, in an almost mystical affirmation of the power of nature, he told an American audience: 'I live a third of a mile and over six hundred feet above one of the world's most ferociously rocky coasts: and although I've only

consciously painted three or four "landscapes" since 1945, I don't doubt for a moment that the enormously powerful rhythmic energies of the granite outcrops beneath my feet transmit certain rhythms straight up through the soles of my shoes every minute of the day.'[2]

Then, towards the end of his life, for his Tate retrospective in 1998, Heron went down to Ben Nicholson's old studio above Porthmeor Beach and set up on the wall one last canvas. He had grown old like Prospero, and after exploring 'the continent of colour' and pushing the exploration to extremes he could say, like Prospero, 'I have bedimmed the noontide sun.' This last oil painting was big as a room, with brush-drawn lines of mauve, black, green and yellow; the title, merely a memo to history, was *29–31 January: 1998* (fig.33). The yellow clearly and startlingly delineates the shape of Eagles Nest. It was a sign off, and if it was a riddle, it was a sublime riddle, a riddle packaged in Chinese boxes, a challenge. There had been buried clues in his writing about the nature of his own art; he had written more again in the 1980s and had lectured extensively about his own non-figurative painting, carefully analysing the effect of colour on colour, of what happens at the borderline between two colours. He had practised absolute abstraction. Now here was a clear verbal meaning, an acknowledgement that Eagles Nest had been the centre of his painting for more than forty years. Enter stage centre that old joker duality: the balance between figurative content and abstraction that had featured so much in Heron's struggles in the 1950s.

One of those oblique insights into the nature of Heron's own art had been contained in his essay *Art is Autonomous*, written in 1955. Heron did not claim that art was uninfluenced by society, arguing instead that the artist could not plan the effect of his art on society, and that if he tried to, he lost the freedom without which art is nothing. 'This is the paradox which lies at the heart of the mystery of artistic creation,' he wrote. 'The meaning which a work of art has for society is not the same as the meaning that the artist was conscious of putting into it. This is because a work of art is not just a telephone exchange which facilitates straightforward communication. The work of art is in some profound sense an independent, live entity. It has its own life. It draws nourishment from its creator that he was

33
29–31 January: 1998
Oil on canvas
182 × 243.8
Collection of the
Artist's Family

34
Patrick and Delia
Heron at Cot Valley,
St Just 1959

35
Rembrandt
*An Old Woman –
The Artist's Mother (?)*
*c.*1629
Oil on canvas
61.3 × 47.3
The Royal Collection

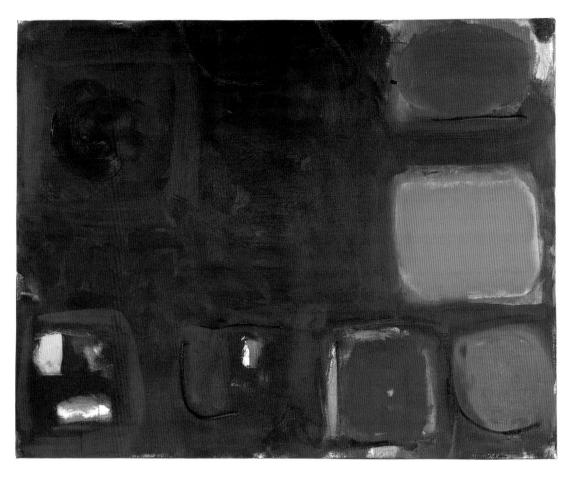

totally unaware of having put into it: and it redistributes nourishment to the spectator (including the artist himself, for he also is merely a spectator once the work is completed) … That is why I say that to demand a certain result from art in advance is utterly to misconceive the central creative process itself. It is to suppress spontaneity: to batten down on the subconscious.'[3]

By the time of the Waddington group exhibition of 1959 Heron was pushing colour around on canvas, painting irregular discs and lozenges (roundish-edged squares or oblongs) on a field of colour. Reaching towards the rich sonorities of stained glass, the colours were brushed softly, loosely; green and red shapes glowing out of brown; yellow, blue, venetian in a field of dark grey; a soft, rough, dark-edged lozenge floating against a cadmium field, with another darker-toned lozenge, and a bright lemon rectangle. The shapes in these canvases were sometimes bunching, usually floating off towards the edges – the edges that, Heron said, constituted the first four formal statements of any composition.[4] He was exploring the spatial effects of colour and brushwork liberated from figurative elements, remembering all the time: 'Even in the most highly figurative of masterpieces the painter knows that it is not Rembrandt's mother's nose he is looking at, but a miraculously ordered mosaic of interleaved, overlapped, opaque, transparent, soft-edged, sharp-edged, rounded or squared, separate brush-touches … A painting's greatness, or otherwise, doesn't depend on that information about the nostril (or about any other of the myriad subjects available): it depends upon the organisational significance,

36
Black Painting – Red, Brown, Olive: July 1959
Oil on canvas
96.5 × 121.9
Private Collection

37
One Form: September 1959
Oil on cavas
35.6 × 45.7
Collection of the Artist's Family

satisfaction, harmony, architectonic coherence – or whatever else you like to call it that those paint marks across that flat surface evoke.'[5] He was, of course, once again describing his own work.

If Heron's writings had established his reputation as a critic, his painting was catching up by the late 1950s. The second John Moores Liverpool Exhibition was held at the Walker Art Gallery in 1959. The first exhibition had established this event, founded and funded by a philanthropic Merseyside football pools millionaire, as Britain's foremost showcase for contemporary art, a position it would maintain through the 1960s. Within the show a select group of twenty-five French and twenty-five British paintings were put forward to an international jury to be considered for the grand prize. Patrick Heron won it with *Black Painting – Red, Brown, Olive: July 1959* (fig.36).

Most of Heron's paintings of this period were brushed in quite quickly, though occasionally, to prevent colours mixing on the canvas, he would allow a body of colour to dry before moving on. He would balance the weight of one colour against another in deciding the size of discs and oblongs; he would paint them out, sometimes leaving shadows of their former selves. Or he would allow them to overlap, or allow the larger field of colour to encroach on them. No element was more important than another. Since he felt that the stripe paintings had been 'the most radical paintings in the world', he had been tempted by the idea of making a painting with a single colour, as the French artist Yves Klein was doing in the 1950s (and decades before in Moscow, Kasimir Malevich had pointed this way with *Black Square* and a series called *White on White*). Heron's *One Form: September 1959* (fig.37) – a single red, squarish lozenge floating in atmospheric grey – came close; but a painting of one colour ceased to be a painting, he said, because it wouldn't have any internal life.

The following year he had two solo shows of this run of paintings: one was his first with Waddington, the other his first in New York, at the Bertha Schaefer Gallery in April, when, he said, he 'was made very welcome indeed'. It was the consummation of his honeymoon with the American art world. He had known Clement Greenberg since the influential American critic had visited him at his flat in Holland Park in 1954, and Heron admired his acute mind, keen eye, and writing, like his own, based on the formalism of Fry and with a feel for the materiality of painting, the brush strokes that constitute Rembrandt's mother's nose rather than that organ itself.

Greenberg had been a Trotskyist, making his name with a rigorously classic Marxian analysis of the collapse of bourgeois culture and the evolvement from it of the artistic avant-garde. Despite discarding the outward trappings of the Trotskyist/Marxian view during the McCarthy years, his old determinist view of cultural development survived alongside a new belief in the autonomy of art, so his own subjective views often appeared persuasively in print as the march of historical inevitability. Greenberg noticed (to his surprise, he said) that the centre of cultural gravity had shifted to New York, and, as it now looks in hindsight, decided that if he could give history a helpful nudge along the path, he would.[6]

By the time Heron showed again with Bertha Schaefer in 1962, the whiff of cordite was in the air. He felt distinctly that the generation of American artists following on from the Abstract Expressionists, and with Greenberg as their talisman, were beginning to proselytise their own art at the expense of the British. By 1965 he was certain, and by the end of the year diplomatic relations had been broken off. Firstly, in a speech at the Institute of Contemporary Arts in London, Heron denounced Greenberg and all his works. Next, he sat with Greenberg on the selection panel for that year's John Moores exhibition, and was infuriated when Greenberg appeared to patronise British art by first insisting on including examples of English landscape painting in the show, and then on putting them up for the prizes (he failed in this second objective). Finally, Greenberg was uncomplimentary about Heron's third show with Bertha Schaefer. Relations did not improve – when Greenberg died in 1994, Heron wrote an unforgivingly savage letter to his patron David Thomson about the critic's failings, which ended: 'RIP. Or not, as the case may be.'[7]

Once Heron had started fulminating about the 'imperialism' of the American art world, he followed up with two articles in *Studio International* in the late 1960s, and concluded with an article totalling almost 14,000 words and running over three days in the *Guardian* in 1974.[8] Given his initial welcome to the Abstract Expressionists, Heron's reservations about them were understandable, both critically and psychologically, for a painter who had made his own way towards abstraction by a close study of the modern French masters. He was not the man to adopt the latest hem length, but even Greenberg had written that 'the first English critic to take the new American painting seriously was, to the best of my knowledge, Patrick Heron'.[9] Heron saw from the first, as most but not all critics still do not see, that Pollock's reputation depended at least as much on the impact he had made as on the quality of his work. In the popular imagination, Pollock had become the two-fisted, boozing, pigment-ejaculating Hemingway of painting. That was the legend, and, as Carleton Young said in a famous line from *The Man Who Shot Liberty Valance*, when the legend becomes fact, print the legend.[10]

Heron's detractors tended to assume that the centre of a movement was the only place to be, and that anywhere else was out in the sticks, and work done on this periphery was of secondary value. Yet Picasso after about 1917 was not part of a movement, nor was Braque. Miró was never in any movement, though he was sometimes described as surrealist, nor was Matisse after the Fauve years. Heron had nothing in common with his St Ives friends, nor they with anyone else. But Abstract Expresionism was a movement, was heavily promoted, and, maybe inevitably, those looking for trends tend to think that forward momentum only comes from movements – that is probably why Picasso was so undervalued in so many quarters at the time of his exhibition in Avignon at the end of his life.

The first mistake Heron made was to claim that good but limited British painters were modern masters. He was loyal to a fault, and this, in a critic, is a weakness. Heron was fighting back in the 1960s and 1970s against what he perceived as a dangerously and unjustly prescriptive approach to developing art history that wrote St Ives and London out of the plot. He felt under pressure, too, from young British artists in the Situation group, who had, from the early 1960s, discounted their elders in St Ives as living in a rural backwater, and also from the pro-American pro-Situation British critic Lawrence Alloway, who had pronounced the St Ives painters a landscape-based anomaly.

Heron's second mistake was that in trying to make the case that there was a dialogue between New York and the London–St Ives axis during the 1950s, and, in pointing out with perfect accuracy the occasions and dates on which paintings had been done and Americans had seen British work, he seemed to

38
Patrick Heron at
the Bertha Schaefer
Gallery, New York 1962

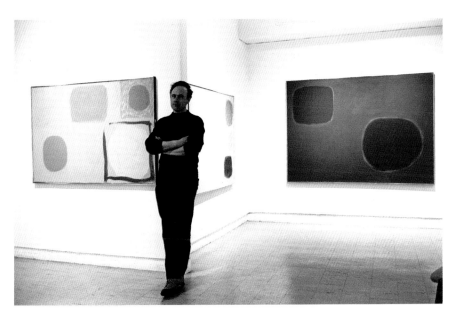

suggest plagiarism. In visual arts the shades of difference between influence and plagiarism can be minute but crucial: from 1953 the American artist Morris Louis had been soaking his colours into the canvas, a technique developed under the influence of the New York-based artist Helen Frankenthaler. These dyed-in colours on canvas were part of what had become the Greenberg school's *reductio*, the flatness of the picture plane as a be all and end all, 'at-onceness' the goal of all painting – one of those clunking coinages of

Greenberg's prose that fortunately never became currency. However, in 1962 Louis began to use opaque colour again to cover his canvases with stripes of colour. The following year, after Louis's early death, Greenberg wrote: 'His art would have evolved anyhow, I feel, towards intenser and more opaque colour, and vertical stripings were already emerging from under his "veils" in the previous years.'[11] This was disingenuous, written as though Louis and Frankenthaler never saw anything but each other's art or that of fellow Greenberg protégés such as Kenneth Noland and Jules Olitski. Heron had painted his stripes in 1956 and 1957. Greenberg had seen them at the time, so Louis knew of them, but a mention of a British painter would have sat uneasily with the march of history. No wonder Heron was angry.

Finally Heron wrote in his lengthy article for the *Guardian* in 1974 that it was known that the Central Intelligence Agency in America had used Abstract Expressionism to promote the notion of western cultural freedom. Most of his assertions were true – the American magazine *Artforum* had already published articles in 1973 and 1974 alleging, among other things, that the Museum of Modern Art in New York was deeply involved in cold war propaganda.[12] And many years later the *Independent on Sunday* produced evidence that the Fairfield Foundation, which had been set up by an art-loving American millionaire named Julius Fleischmann and had funded the ground-breaking *Modern Art in the United States* show in 1956, was a CIA front.[13] Since then,

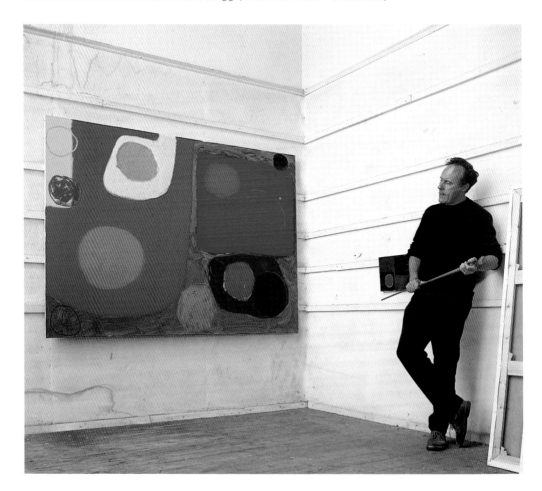

however, a counter-revisionist school has argued that any artists on offer, just as long as they weren't communist fellow-travellers, would have served the CIA purpose as well as Jackson Pollock, and that neither the CIA nor MoMA at any point harboured monolithic views. To anyone with experience of large organisations, this looks closer to probability than the conspiracy theory.[14]

After the heyday of Abstract Expressionism in the 1950s, Greenberg was personally responsible for putting a series of shows together that helped chosen painters on their way, and particularly an exhibition at the Los Angeles County Museum of Art in 1964 called *Post-Painterly Abstraction*, another accurate but cumbersome Greenberg term (painters like Heron who used the brush to work up texture were 'painterly', painters who stained were 'post-painterly'). By now it was an open secret that he guided the direction his painters' and sculptors' work should take. 'An exceptional critic may well assist in *orchestrating* a group of individual artists until it is apparent that their joint activity constitutes a movement,' Heron wrote drily, 'but the paintings should exist before the explanations…'[15]

Doubtless Heron was remembering a letter to him from Greenberg written in 1958 as the critic returned to New York from a visit to Britain during which Victor Waddington had shown him five new Heron paintings. 'Always, I felt, a few too many discs or rectangles were put in,' Greenberg wrote, '– to prevent that wonderfully original color of yours from realising itself, as all real color must (whether Matisse's or Titian's or Vermeer's) in relatively large, undifferentiated areas. I also felt rather presumptuously that every one of the five paintings could have been decisively strengthened by simply or mechanically wiping out every silhouetted form that was less than a foot and a half away from the edge of the canvas, that is, by bunching and clearing.' Then he added: 'If only to do me a very personal favor, I wish you would, for fun, paint one picture that way and let it stand for a while.'[16]

Heron didn't; and the first of his shows at the Bertha Schaefer Gallery, held in 1960, in which all the paintings but two had been done after receiving this advice from Greenberg, showed that he had no intention of swallowing the critic's prescription, not even for fun. He enjoyed the debate, and walking over Zennor Moor with visitors in later years he would play both parts, Greenberg and Heron, in a dialogue in which Greenberg urged bunching the 'silhouetted forms' towards the centre of the canvas, and Heron extolled the virtues of Bonnard's all-over mesh design. Greenberg's letter supports the view that even in the 1950s he already regarded himself as orchestrator-in-chief of the destiny of art in the second half of the twentieth century. Heron did not slot into this scenario. As early as 1959, Hilton Kramer, the editor of *Arts*, had written to Heron from New York to warn him to bring a long spoon to his meetings with Greenberg, who had, he said, become adviser to the gallery of French & Co., a 'blatantly commercial' operation.[17]

Heron's daughters are convinced that this affair damaged Heron's reputation at home as well as in the United States among people who felt that he had gone too far in his articles. It certainly failed to put a dent into Pollock promotion.[18] Now, though, Heron had got rid of his anger over New York chicanery. It was time to turn back to painting full time.

39
Patrick Heron at Porthmeor Studio in front of *Fourteen Discs: July 20 1963*
*c.*1963

5
Light Years

Until his sustained outburst against what he termed American cultural imperialism, Patrick Heron had mostly kept clear of writing during the 1960s. There were a few catalogue introductions including, for the first time, notes explaining his own painting, and he collaborated with Alan Bowness in writing an obituary for *The Times* when Peter Lanyon died in August 1964 after a gliding accident in Somerset. This was a period of advance in his painting. In 1962, as the ink was drying on a catalogue to an exhibition of his work at the Galerie Charles Leinhard in Zurich in which he told his public that he never drew in the elements of his compositions, he picked up a stick of charcoal and did just that. Zen philosophy was the flavour of those years: Eugen Herrigel's *Zen in the Art of Archery* was a cult book, and though there is no evidence that Heron had read it, Hepworth, Wynter and Wells had; so had Braque. Heron's new approach, drawing in the outlines of a huge painting in a matter of seconds, was absolutely in the spirit of the Zen archer losing himself in contemplation until he had shed all personal concerns and was at one with his bow, then loosing the arrow at the target (unerringly, if we are to believe the apologists).

By the 1970s, he was still beginning with the lightning-fast initial drawing, but what followed this was sheer endurance. There were three factors: the maximum luminosity to be gained from the white of the canvas would be achieved by painting only a single coat of pigment; the individual fields of colour had to be finished in one go, otherwise where the paint dried after a pause a tide mark would show; and on no account should one field of colour overlap another, because this edge, this border, was where the 'colour of colour' changed, where the colour in one sector affected the colour in another sector with maximum intensity.[1] This intensity was greater if the line meandered, hence Heron's description 'wobbly hard edge', which, of course, was also a reminder to the American Post-Painterly Abstractionists championed by Clement Greenberg that he knew all about hard-edge abstraction, and was at the very least abreast of it with his own version. Achieving this intensity entailed the use of small, soft watercolour brushes at the border of one colour with

This was a prelude to Heron discarding the atmospheric overlapping of colour and starting to explore what happened at the edges, originally delineated by the strokes of charcoal, where colour met. But in 1967 he smashed a leg while he was with Bryan Wynter messing about in a kayak off that 'ferociously rocky coast', was unable work at his oils, and began to explore gouache; his easy affinity for the medium had been prefigured in the almost watercolour thinness and fluidity of his washes, more turpentine than pigment, in some of the garden paintings from 1956. When he was fit to return to his studio, he started the sequence of big paintings that would last him the next ten years.

40
Scarlet, Emerald and Orange: July–September 1976
Oil on canvas
101.7 × 152.5
Tate, London

another, so that they would touch exactly but not overlap by even a millimetre. Because Heron desired the same texture of paint across the whole canvas, he had to fill in all the colour areas with the same tiny brushes.

When Heron was in Austin, Texas, in 1978 giving the E. William Doty lectures, for which he had painted an accompanying exhibition, he told his audience how he had painted the thirteen-foot-wide *Long Cadmium with Ceruleum in Violet (Boycott): July–November 1977* (fig.41):

'Boycott' was included in the title because Geoff Boycott is the greatest living batsman [here Heron kindly explains what cricket is] … and as I started to apply that very large area of cadmium red with my little Japanese watercolour brush … I knew I had a marathon performance of sheer paint application ahead of me. In fact, it took nine hours non-stop to cover that area with that red … Where Boycott came into it was that he was just walking up to the wicket to open the English innings against Australia at the very second I commenced (I told you I had the radio on when painting) … So, naturally, I identified with my fellow-Yorkshireman … By the way, Boycott went on and batted the first of three historic innings, thus winning the series against Australia virtually single-handed last summer![2]

Besides his pride in his Englishness and his by now surely vestigial Yorkshireness, and his enjoyment in baffling a Texan audience, this story illustrates how much sensuous pleasure Heron had sacrificed in the speedy manipulation of paint; all the speed was in that half minute of drawing. Still, Heron talked orgasmically of reaching the climax of the painting: 'The moment the last bit of white was filling in … zoom! It was as if a great hot flood had come on.' And again: 'The moment you filled in the last bit of white, the whole world would suddenly pulse … One came to relish the last moments of those paintings, knowing that that would happen.'[3]

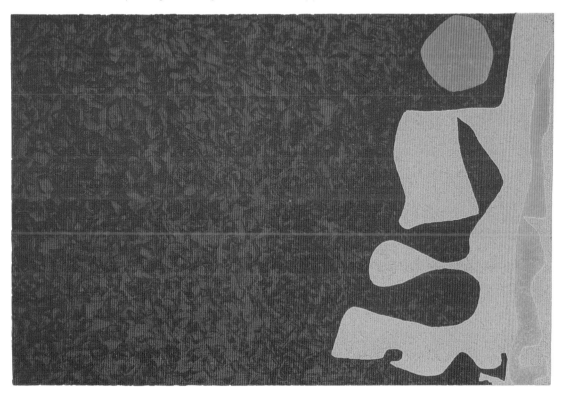

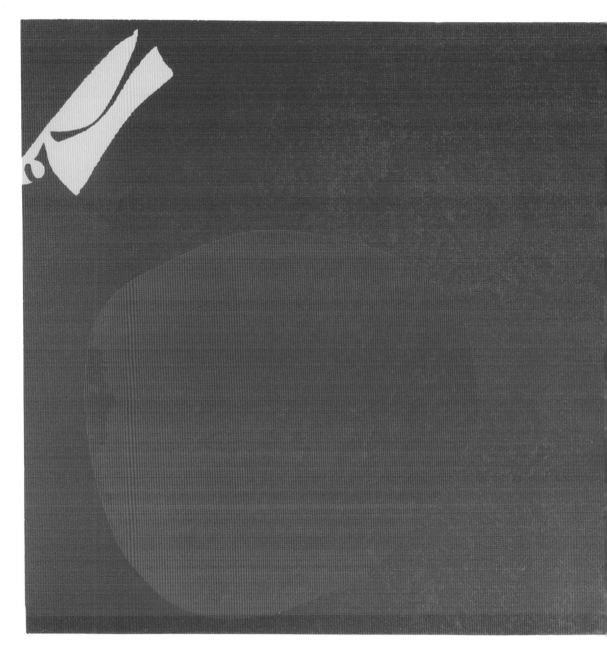

41
*Long Cadmium with
Ceruleum in Violet
(Boycott): July–
November 1977*
Oil on canvas
198 × 396.2
Waddington Galleries Ltd,
London

The paintings from the exhibition in Texas are full of the 'colour of colour', and in discussing them Heron referred to the visit he had paid to Braque's studio in 1949, when Heron had pointed to the difference in texture between the lavishly spread pigment of the late landscapes and the thin 'turpsified' painting of the *Ateliers* series; Braque had responded by explaining that one involved *'l'émotion directe'*, the other was the result of long contemplation.[4] His own paintings of the early 1960s to the late 1970s involved both, Heron said – the Zen archer coup took care of *l'émotion directe*, and the rest was long contemplation. But however much the colours threw back light at the viewer, however irregular the discs and squares, however gently the intricate brushwork made the surface pulse, the broader freedom of the earlier paintings had been sacrificed. In these later paintings blue scarcely figured: the colours were high pitched and hot, the pigment squeezed straight from the tube: scarlet, emerald, orange, venetian, vermilion, violet, lemon. As the painter Alan Gouk wrote some years later: 'The sometime stridency of Heron's colour is a seeking for some more elemental response to the spirit of place, the radiant brilliance of the light of the Cornish coast which has filled his entire living environment from 1956 onwards. Not a descriptive response, but a response in kind…'[5]

42
Balcony Window with Moon: 1954
Charcoal on canvas
101.6 × 127
Collection of the
Artist's Family

While Heron was at Texas University he developed pneumonia. Severely ill, he came home to recuperate very slowly; and then in 1979 Delia, full of life and love as always, died suddenly when a blood clot reached her lungs. Patrick was hopelessly cast down, could not paint, and only slowly began to piece life together again when he took a holiday in Italy with his friend and dealer, Leslie Waddington. For the first time in more than a quarter of a century he took out a pencil and sketching pad and began to draw the places around him. In the succeeding years as well he drew on holiday with Leslie Waddington and Waddington's first wife, Ferriel, in the Dordogne, where they visited the house that the architect Fello Atkinson, an old school friend, had built for himself.

Heron's line in these drawings is swifter than Ben Nicholson's, but has the same nice placing, a wiry spareness of means that encompasses volume and measured distance. The economy recalls *Balcony Window with Moon* (fig.42), the virtuoso drawing in charcoal on canvas that he made in 1954: two tall-masted pleasure yachts under a disc standing for a full moon, on a horizontal stretch of bay bounded by the balcony railings in the foreground and low hills in the background, and bisected vertically by a window frame: calm, lucid, bearing all the elements of the later abstracts. The charcoal had made, what? Four dozen thick strokes on the canvas? But there is a more complicated line in the later drawings, well illustrated in *View from Highertown, St Martins, towards Tresco: Isles of Scilly* (fig.43), of the mid-1980s, with its scribbled line articulating the shapes that appear in his paintings. And here, with nothing much more than signs for buildings and tall palm trees, they instantly evoke recession across a seascape scattered with islets before the larger island of Tresco. This was a quality he picked out ten years later in an essay on Constable's drawings:

43
View from Highertown, St Martins, towards Tresco: Isles of Scilly:
c.1985
Pencil on paper
21 × 29.9
Collection of the Artist's Family

at every stage in our contemplation of a drawing we are measuring the various depths to which our eyes sink into the illusionistic space the drawing evokes: thirty yards to that tree – seventy yards to that bank – two hundred yards to that hedge – eight-five yards to that gable-end – five miles to that cloud – stop; stop; stop; the eye plunges straight ahead through the illusionistic space of the drawing, down a hundred lines of vision to a 'stop'. I have always felt that our immensely rapid successive penetrations of these related depths constitutes an experience of a sort of contrapuntal harmony.[6]

And the whites in Heron's drawings, that pregnant emptiness full of suggested light and colour, seem to look forward to the white expanses of primed canvas he would leave on his final paintings, between the carefree filligree of the scribbled lines of paint.

44
Patrick Heron and
Richard Rogers
in Moscow 1988

45
Window at Tate St Ives
1993

The 1960s onwards were years of worldly success as well. Heron had followed his John Moores prize of 1959 by winning the silver medal at VIII Bienal de São Paulo in 1965; he had represented Britain at the first Sydney Biennale in 1973 and had lectured right across Australia and in São Paulo, Brasilia, Rio de Janeiro and Tokyo; he picked up honorary doctorates and fellowships like hitting the jackpot with a one-arm bandit; Texas made Patrick and Delia honorary citizens. He became a trustee of the Tate in 1980, visiting Moscow and Leningrad in the late 1980s to lobby vigorously but unsuccessfully to ensure that the Matisse exhibition with its important works from Russia came to London. The show went to New York and Paris instead, and he briefed the *Guardian* on the Tate's failure to land the show: everybody, of course, knew who was behind the article. He visited New York to see some paintings with the Tate's chairman of trustees, Peter Palumbo, who insisted on flying by Concorde. As it happened, the pilot knew who Heron was,

largely as a result of his constant championing of Concorde in the press – a very unfashionable position to take – and told him: 'If I had known we had Patrick Heron the artist on board I would have invited you up earlier.'[7] He appeared in a BBC television *Omnibus* programme, and London Weekend Television devoted a *South Bank Show* to him. He accepted a CBE during the administration of James Callaghan but turned down a knighthood from the Thatcher government, though he had respected Mrs Thatcher for her robust

support during the Matisse affair.[8] There was one worldly failure: he attacked in print successive administrations for ruining art education and got nowhere, provoking only a sneering letter from Kenneth Clarke, then Secretary of State for Education.[9]

In the 1990s Heron designed the big stained-glass window for Tate St Ives, a fanfare to carry the visitor through the entrance hall to the galleries beyond – he collaborated on the project with Julian Feary, his son-in-law, of Feary and Heron, the architects' practice Julian ran with Katharine (fig.45). Patrick collaborated with Feary again on *Big Painting Sculpture* at Stag Place in Victoria, London, a large kinetic structure with coloured panels that swing in the wind, of which there was enough among those tall office blocks to remind him of Eagles Nest.

Principally, though, Heron was developing a late style in his painting. He believed that Abstract Expressionism had stopped short because, having succeeded with the grand gesture, its first cataclysmic discovery, it could find nowhere else to go, neither forward nor back. 'We are all living the same spiritual life, whether we recognise the fact or not; only it sometimes helps people to live it more successfully if they know what they are doing,' Patrick's monastic brother Michael had written to him when they were both young. Patrick equated the spiritual with the continent of colour, better than sex, he said, better than anything, as a matter of fact. 'All colour is shape and all shape is colour,' he wrote. 'There is no shape that is not conveyed to you by colour, and there is no colour that can present itself to you without involving shape. If there is no shape then the colour would be right across your retina.'[10]

46
Afternoon Blue:
July 1983
Oil on canvas
198.1 × 274.3
Private Collection

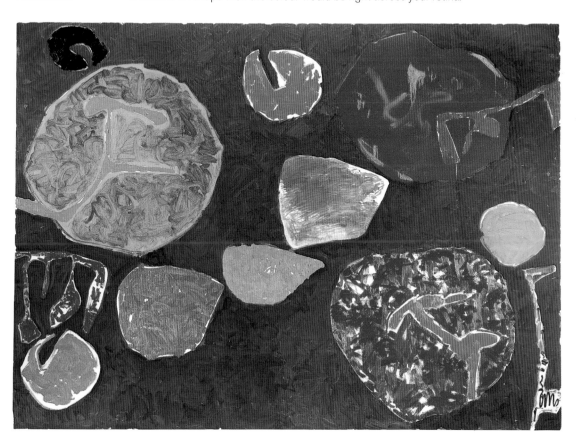

It was the old pursuit, but now he had loosened up. When Heron had a retrospective at the Barbican Art Gallery, London, in 1985, the meticulously painted, big, colour-full, show-stopping canvases of the 1970s were succeeded by paintings brushed in fast with the linear agility of the 1950s, in which the white of the canvas and the linear colour and the scribbled fields of pale mauve and brilliant yellow and pink and purple are not the simulation of light: they *are* the light, unfettered by representation and free from theory. And had he also, after 1979, looked back at the gouaches he had made after his kayak accident, with their sensual flowing and flowering of colour into the wet of the paper? At any rate, he was mixing his colours again, and they had become cooler, his brushwork broader, scrubbed in, scribbled, lemon flecked with white, sea green agitated by zigzag lines, pale pink splattered with pale blue blobs, a patch of red that looks as though it may have run and been coaxed into one of Heron's hook-like shapes.

Heron had visited Sydney twice, in 1967 and 1973, and did so again as artist in residence at the Art Gallery of New South Wales in 1989–90; he walked to his Sydney studio through the botanical gardens each morning and they came as a liberation to him, just as Eagles Nest had in 1956, and he began to call some of his canvases garden paintings once more. But this time leaf and frond shapes, like Matisse's, had eased their way back into the paintings; large areas of white acted as another colour, the brightest colour of all (fig.49); Heron would squeeze glistening white trails on to the matt white of canvas; there were fields of colour and areas of broken colour; there were pale blues, pale mauves, pale pinks, bright lemons and scarlets. He did some portraits as well, including Jo Grimond and A.S. Byatt (fig.48), and, yes, he said, it remained possible to make a portrait which was also a painting. It was, but they were not as good as his other paintings. The necessity for a likeness was a different kind of reality that weakened the reality of his kind of painting. Only Picasso has

47
Sydney: November 17:
1989: I
Gouache on hand-
made paper
58.4 × 76.2
Collection of the
Artist's Family

managed this kind of portrait, and the best portrait Heron ever did remained the full-blooded likeness of Delia painted in 1945 (fig.16): a touch of local colour to the head, but mostly resonant blue and red, more reminiscent of Matthew Smith's early work than of Matisse.

To painters of Alan Gouk's younger generation, Heron was a link with the masters, particularly Braque and Matisse in France; and Heron, like Matisse's British contemporary Smith, had not painted out of a sense of inferiority but had set out to learn from the old masters of modernism and to match them.[11] And now, in his sixties and seventies, he dispensed with evenly brushed paint and luxuriated in fast, gestural brushwork, a network of lines painted in the way he had drawn the outlines of his 1970s compositions, but this time comprising the whole picture. He explored the cooler regions of the continent of colour, the paintings became tactile, touchy-feely even: Heron, who had been fastidious in not getting paint on to himself or his clothes, now chuckled as he smeared the canvases, smudging his handmark in scarlet on his penultimate big canvas, *26–28 January 1998*, like Titian in the years of his last great paintings.[12] He meant, somehow, to transfer the sensuousness of the gouaches to the huge canvases.

In the 1980s, the Canadian David Thomson began to collect Heron. A warm friendship grew between the young businessman and the old artist, touching to

67

49
4–5 September: 1996
Oil on canvas
182.9 × 91.4
Collection of the
Artist's Family

50
2 July–3 July: 1994
Oil on canvas
198 × 274.3
Collection of the
Artist's Family

observers and as vital in helping to carry Heron through the radical work
of his last few years without worrying about losing his market as Leslie
Waddington's support was at key times in his career.[13] Heron had gathered
all his experience and all his powers for this last foray into the unknown. Some
of his most beautiful paintings of the early 1960s had been the blue paintings,
with aquamarine or turquoise or green scumbled over a darker blue beneath
(fig.52). Heron was working too fast now for these niceties of technique,
working fast at inventing new colours and colour combinations, so he found
other means. A thirteen-foot canvas, *25 May–18 June: 1994* (fig.54), has a big
vat of indigo splashed with mauve blobs – no, it's not a vat, it's the grand piano
of his 1943 breakthrough painting (fig.14) rendered again in reverse. There is a
green plant-like shape on this 'piano', and, where the music stand of the 1943
painting stood, is a polygon of green smeared and scrubbed into orange;
around that are pink, leaf green, turquoise, mauve, and a wide, tapering twist of
lemon careening down the canvas from the top: this is memory speaking, the
memory of an interior still based a little on Matisse but mostly on the gathered
experience of Heron's own explorations over the previous half century; and
the collective memory of his past adds up to the future that Abstract
Expressionism did not find.

 In 2001, Tate St Ives mounted an exhibition of Heron's garden paintings,
dating from 1956 and from his last years, and surrounded it with work by
painters whom he admired. It clearly showed that the early garden paintings
took some of their manner from Sam Francis and were closer to Heron's own

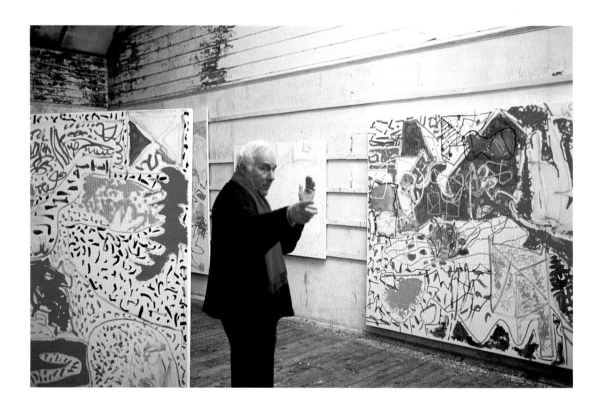

late gouaches than to the late canvases. The grey of the galleries was repainted white like the walls of Eagles Nest, and in the final room, hung with only three large canvases and two small ones all from the 1980s and 1990s, the effect of the light and colour thrown back was sensational, in the double sense that means both visual sensation, and the physical shock of colour liberated into brilliance: a flaming orange surrounded by pale mauve and a sea of pale green eau-de-nil – *28 January: 1983 (Mimosa)* (fig.53) – or a field of vermilion in white with a block of cadmium and with lemon flecks and stripes – *Red Garden Painting: June 3–5: 1985*. The intensity of colour in these pictures was greater than in anything Heron had previously done, but, modulated by cooler mixed colours, subtler. The light and rhythm of these canvases were the parallel experience to nature of which Heron had written, but he had also, many times, said that he believed that figuration would return to painting in a different form, and these paintings of his last two decades are the answer to the puzzle of that last canvas, *29–31 January: 1998* (fig.33), showing Eagles Nest, not in perspective like his pencil drawings, but as an ideogram, flat and lying on the picture plane.

At the dinner celebrating the opening of the Tate retrospective in June 1998, everybody could see that Heron was delighted, studying the hang, introducing old friends to new friends, painter friends to writer friends, journalist friends to his collector and patron, David Thomson; though he did remark tersely in his speech, 'Twenty years too late.' Twenty years before, Delia had died; but he was probably being critical of the Tate's former policies, not sentimental. Heron was approaching 80 now, and to his lifelong asthma were added heart problems. By the beginning of 1999 he was complaining that these days his feet wouldn't move, but he meant that they wouldn't move as fast as he would have liked, and he needed friends to come to take him walking.

51
Patrick Heron in Porthmeor Studio packing paintings for possible inclusion in *Big Paintings* exhibition at Camden Arts Centre, August 1994

52
Blue Painting: September 1961–September 1962
Oil on canvas
121.9 × 182.9
Private Collection

53
28 January: 1983 (Mimosa)
Oil on canvas
50.8 × 60.9
Collection of the Artist's Family

54
25 May–18 June: 1994
Oil on canvas
198 × 396.2

Collection of the
Artist's Family

His brother Giles came to stay for a week in March 1999, and they were both cheerful when Giles left on 18 March. The next day Heron resumed work on a set of soft-ground colour etchings he had been making with the printmaker Hugh Stoneman. These were being prepared as single prints but also to be issued as a box set called *Brushworks* (fig.55). The back of the box was to be art based on the map of Australia; it didn't finish looking like Australia, but this was work spiritually dedicated to Heron's other Cornwall. Stoneman had been coming from his studio in Penzance to Eagles Nest every Friday since Christmas. Heron was physically frail, pausing in his work as he breathed in, drawing vigorously on the out-breath, knowing exactly where he was going. On this day, he proposed that the two of them should have a glass of wine each for lunch. No, said Heron's PA, Janet Axten, firmly. It was his cheque-signing day. He finished the day's work on the etchings on a high note with a sequence of nine simple line drawings as motifs for the box.[14]

The next morning Monica Wynter drove over from Penzance, where she now lived, to take him for a walk and cook him lunch. At the front door she got no answer and called the police. Inside they found Patrick where he had died climbing into bed the night before, like a young boy asleep, in his room with the big window overlooking the mirror of the Atlantic. His heart had simply stopped working.[15]

When the Tate retrospective closed, Patrick had looked back on his life's work and he saw that it was good. But Katharine and Susanna cajoled him into embarking on a series of one hundred gouaches after the Tate retrospective. He made it to forty-three, stopping there because when he spread them out they covered the carpet of his sitting-room at Eagles Nest.[16] He carried into this series the sensuousness of the old gouaches, plus the joy

55
Collection of studies for the portfolio box of The Brushworks Series: 1999
Pen on paper
15 x 18.5 each
Collection of the Artist's Family

56
1 January: 1999: I
Gouache on paper
20.3 × 26.7
Private Collection

and light of the big new canvases. There is not a gouache among them that can be read as typical, but take one of them, *1 January: 1999: I* (fig.56): it has green massed to the right, overlaid with sponged white discs roughly outlined with thick red brush lines. And, a rare thing, there are dabs of black, some overlaid with congeries of rivulets running into tiny deltas where the wet green has run. When I can't think of a colour, I reach for black, Matisse once said. It had been a staple for him. To the left of the gouache, green and black magnified corpuscles, like the signature motif of his old friend Sam Francis, break off from the mass and float into space. It could be a detail of sunlight shining through leaves in a Monet of the garden at Argenteuil.

Finding parallels in nature was not what Heron meant when he had remarked that figuration would return one day, but they signalled Heron's indifference to the old perplexities over figurative and abstract painting. These little gouaches, only nineteen centimetres deep by twenty-six centimetres wide, constituted the whole experience of art, and were autonomous, their own world.

Notes

Patrick Heron's correspondence and other documents are in the possession of his family. They have kindly allowed me some access, but at the time of writing the papers have not been sorted into an archive and their future is not settled.

Introduction

1 John Updike, 'Jackson Whole', review of the *Jackson Pollock* exhibition at the Museum of Modern Art, New York, and the Tate Gallery, London, in 1998–9, and of the catalogue for this exhibition by Kirk Varnedoe and Pepe Karmel, *New York Review of Books*, 3 December 1998, p.11

2 Obituary of Patrick Heron, *The Times*, 22 March 1999

3 Patrick Heron, 'The Americans at the Tate Gallery', *Arts* (NY), March 1956, reprinted in Mel Gooding (ed.), *Painter as Critic*, London 1998, p.100

4 Heron sat in on page production, helping to check proofs and place photographs. Despite this, in post-Caxton pre-computer technology, page layouts had to be dictated by phone for northern editions printed in Manchester, and inevitably the odd picture appeared flipped left to right or upside down

5 Alan Gouk, 'Recent Paintings', *Patrick Heron*, exh. cat., Barbican Art Gallery, London 1985, reprinted in David Sylvester (ed.), *Patrick Heron*, exh. cat., Tate Gallery, London 1998, pp.145–51

Chapter 1

1 Matisse, 'Notes of a Painter', in Jack D. Flam, *Matisse on Art*, Oxford 1978, p.38

2 John Berger, *New Statesman and Nation*, 16 June 1956

3 Martin Gayford, interview with Patrick Heron in Sylvester 1998, p.18

4 Simon Jervis, *The Penguin Dictionary of Design and Designers*, London 1984, pp.116–17 (Wells Coates), pp.266–7 (E. McKnight Kauffer)

5 Letter from Tom Heron to Patrick Heron, 5 November 1947. Figures adjusted to approximately their modern equivalent supplied by Victor Keegan, economics leader writer of the *Guardian*

6 Martin Gayford, interview with Patrick Heron in Sylvester 1998, p.19

7 Mel Gooding, *Patrick Heron*, London 1994, p.28

8 Patrick Heron, *Arts*, October 1956, reprinted in Gooding 1998, pp.116–20

9 *Patrick Heron*, London Weekend Television production of *The South Bank Show*, in association with RM Arts, 1986, among many references

10 Patrick Heron, *New Statesman*, 2 February 1952, reprinted in Gooding 1998, pp.60–2

Chapter 2

1 Martin Gayford, interview with Patrick Heron in Sylvester 1998, p.23

2 Ibid., p.22

3 Patrick Heron, in an article on painting the portrait of T.S. Eliot, *Guardian*, 24 September 1988

4 Ivon Hitchens, letter to Patrick Heron, 23 May 1948, Heron papers

5 A.S. Byatt, 'A Riddle around the Edges of Vision', Sylvester 1998, pp.13–17

6 A.S. Byatt, 'Patrick Heron's Paintings', *Patrick Heron: Early Paintings 1945–1955*, exh. cat., Waddington Galleries, London 2000

7 Susanna Heron, conversation with the author, 27–8 December 2000

8 Patrick Heron, 'Ivon Hitchens', *New Statesman and Nation*, 14 June 1952, republished in Gooding 1998, pp.66–8

9 Patrick Heron, 'Art is Autonomous', *The Twentieth Century*, September 1955, reprinted in Gooding 1998, pp.93–9. In singling out the image of electronic energy, Heron was thinking of particular works by Naum Gabo

10 Patrick Heron, 'Ben Nicholson', *New English Weekly*, 18 October 1945, reprinted in Gooding 1998, pp.1–3

11 Patrick Heron, 'Introducing Roger Hilton', *Arts* (NY), May 1957, reprinted in Gooding 1998, pp.128–34

12 Patrick Heron, *The Colour of Colour*, E. William Doty Lectures in Fine Arts, University of Texas, 1978

13 Patrick Heron, conversation with the author, February 1991

14 Paul Cézanne, *Letters*, John Rewald (ed.), Oxford 1941, reprinted 1976, p.316

15 Cyril Connolly, *Horizon*, June 1945, reprinted in Andrew Wilson, 'Between Tradition and Modernity: Patrick Heron and British Abstract Painting 1945–1965', unpublished PhD thesis, Courtauld Institute, London 2000

16 Patrick Heron, 'Pierre Bonnard and Abstraction', *The Changing Forms of Art*, London 1955, reprinted in Gooding 1998, pp.19–25, in a slightly edited form, closer to the article originally rejected by *Horizon*

17 Letter from V.S. Pritchett to Patrick Heron, 1 March 1949, in the Heron papers. Information about the editorial

positions of T.C. Worsley and V.S. Pritchett from Edward Hyams, *The New Statesman: The History of the First Fifty Years 1913–1963*, London 1963, p.169

18 T.C.Worsley, letter to Patrick Heron, 22 April 1950, Heron papers

19 Patrick Heron, letter to T.C. Worsley, 30 April 1950, Heron papers

20 Letters from Pasmore, Butler, Coldstream, de Maistre, Soulages and Moore in Heron papers

21 Michael Heron (Dom Benedict), letter to Patrick Heron, 8 June 1950, Heron papers

22 Patrick Heron, letter to Herbert Read, 14 December 1958, Heron papers

23 Herbert Read, letter to Patrick Heron, 16 December 1958, Heron papers

24 Patrick Heron, letter to Herbert Read, 5 February 1959, Heron papers

25 Andrew Wilson, 'Between Tradition and Modernity: Patrick Heron and British Abstract Painting 1945–1965', unpublished PhD thesis, Courtauld Institute, London 2000

26 Patrick Heron, *Space in Colour*, exh. cat., Hanover Gallery, London 1953, reprinted in Gooding 1998, pp.86–8

Chapter 3

1 James T. Boulton (ed.), *The Selected Letters of D.H. Lawrence*, Cambridge 1997, p.123

2 Susanna Heron, conversation with the author, 27–8 December 2000

3 Anne Olivier Bell (ed.), *The Diary of Virginia Woolf*, II, London 1978, p.53

4 Monica Wynter, conversation with the author, 28 December 2000

5 Patrick Heron, 'The Americans at the Tate Gallery', *Arts* (NY), March 1956,

reprinted in Gooding 1998, pp.100–4

6 Kirk Varnedoe with Pepe Karmel, *Jackson Pollock*, exh. cat., Museum of Modern Art, New York, and Tate Gallery, London 1998, chronology, p.328, et al.

7 John Golding, *Paths to the Absolute*, London 2000, p.139

8 Pollock was born in Wyoming, Kline in North Dakota

9 Patrick Heron, 'Nicolas de Staël', *Listener*, 3 May 1956, reprinted in Gooding 1998, pp.109–11

10 Susanna Heron, conversation with the author, 27–8 December 2000

11 'Heron's Nest', interview with Patrick Heron in *Harpers & Queen*, August 1981

12 Patrick Heron, 'Sam Francis, 1923–1994', obituary in the *Independent*, November 1994, reprinted in Gooding 1998, pp.218–20

13 Patrick Heron, 'Georges Braque: Exhibition of Paintings', *Arts* (NY), February 1957, reprinted in Gooding 1998, pp.122–7

14 Patrick Heron, 'The Monet Revival', *Arts* (NY), November 1957, reprinted in Gooding 1998, pp.135–8

15 Herbert Read, letter to Patrick Heron, 6 August 1954, Heron papers

16 Herbert Read, letter to Patrick Heron, 7 February 1956, Heron papers

17 Susanna Heron, conversation with the author, 27–8 December 2000, during which she pointed out how the size of the studio affected not only the size of the paintings but how they would look in different surroundings. The canvases painted at Eagles Nest sat easily in the house but presented problems when they came to be hung at the Tate retrospective in 1998, whereas the paintings made in the Porthmeor studio naturally adapted to the Tate's walls

18 Alan Gouk, 'Recent Paintings', *Patrick Heron*, exh. cat., Barbican Art Gallery, London 1985, reprinted in Sylvester 1998, pp.145–51

19 Hilary Spurling, *The Unknown Matisse: A Life of Henri Matisse 1869–1908*, London 1998, p.323

20 Alan Bowness, 'On Patrick Heron's Striped Paintings', *Patrick Heron: a retrospective exhibition of paintings 1957–66,* exhibition leaflet, Museum of Modern Art, Oxford 1968, reprinted in Sylvester 1998, pp.135–6

21 Martin Gayford, interview with Patrick Heron in Sylvester 1998, p.48

22 Herbert Read, letter to Patrick Heron, 18 October 1957, Heron papers

23 Andrew Forge, 'Round the London Galleries', *Listener*, 27 March 1958

24 Patrick Heron, 'Patrick Heron writes', *Architecture and Building*, October 1958

25 Bryan Wynter, letter to Patrick Heron, 1 October 1947, Heron papers

26 Patrick Heron, 'Pierre Bonnard and Abstraction', *The Changing Forms of Art*, London 1955, reprinted in Gooding 1998, pp.19–25

27 Patrick Heron, 'American Artists from the E.J. Power Collection', *Arts* (NY), May 1958, reprinted in Gooding 1998, p.150–3

28 Robert Hughes, introduction to *Patrick Heron: retrospective*, exh. cat., Richard Demarco Gallery, Edinburgh 1967

29 E.J. Power, letter to Patrick Heron, 25 February 1970, Heron papers

30 Susanna Heron, conversation with the author, 27–8 December 2000

31 Geoffrey Grigson, letter to Patrick Heron, 21 March 1949, Heron papers

32 Herbert Read, letter to Patrick Heron, 16 December 1958, Heron papers

33 Patrick Heron, letter to Herbert Read, 5 February 1959, Heron papers

34 Katharine Heron, conversation with the author, 23 January 2001

35 Patrick Heron, 'A Note on My Painting: 1962', *Patrick Heron*, exh. cat., Galerie Charles Lienhard 1963, reprinted in Gooding 1998, pp.218–20

Chapter 4. Notes

1 Martin Gayford, interview with Patrick Heron in Sylvester 1998, p.23

2 Patrick Heron, *The Colour of Colour*, E. William Doty Lectures, College of Fine Arts, University of Texas at Austin, 1979, p.26

3 Patrick Heron, 'Art is Autonomous', *The Twentieth Century*, September 1955, reprinted in Gooding 1998, pp.93–9

4 Martin Gayford, interview with Patrick Heron in Sylvester 1998, p.38

5 Patrick Heron, *The Colour of Colour*, E. William Doty Lectures, College of Fine Arts, University of Texas at Austin, 1979, p.21

6 For the intertwining of Pollock's and Greenberg's careers, see Kirk Varnedoe with Pepe Karmel, *Jackson Pollock*, exh. cat., Museum of Modern Art, New York, and Tate Gallery, London 1998, pp.42–7, in which Kirk Varnedoe demonstrates in some detail that from a very early stage Greenberg was guiding the painter in the direction he deemed necessary for the future dominance of American art

7 Patrick Heron, letter to David Thomson, 19 May 1994, Heron papers

8 Patrick Heron, ['The British Influence on New York'], *Guardian*, London, 10, 11, 12 October 1974. The title was Heron's, and was not used. The newspaper headed the articles with quotations lifted from each day's article

9 Clement Greenberg, 'A Critical Exchange with Herbert Read on "How Art Writing Earns its Bad Name"', *Encounter*, February 1963

10 For an entirely sceptical view of Pollock's achievement, see Hilton Kramer, 'The Jackson Pollock Myth I and II', *The Age of the Avant-Garde*, London 1974, pp. 335–41. For a counter-view to Patrick Heron's, which also usefully places the art and criticism of the time, see Charles Harrison, 'Modernism and the "Transatlantic Dialogue"', lecture at University College, London, November 1982, published in Francis Frascina (ed.), *Pollock and After, The Critical Debate*, London 1985

11 Clement Greenberg, 'The New American Painters: Louis, Noland, Olitski', *Canadian Art*, May–June 1963

12 Max Kozloff, 'American Painting During the Cold War', *Artforum*, May 1973, argued that Abstract Expressionism gained much of its impetus from a pervading triumphalist view of American history; Eva Cockcroft, 'Abstract Expressionism, Weapon of the Cold War', *Artforum*, June 1974, showed how the CIA used American culture for political propaganda. Both articles reprinted in Francis Frascina (ed.), *Pollock and After, The Critical Debate*, London 1985

13 'Modern Art was CIA weapon', *Independent on Sunday*, 22 October 1995

14 Francis Frascina (ed.), *Pollock and After, The Critical Debate*, 2nd ed., London 2000. The third section is entirely altered from the 1985 edition, and consists of the continuing argument in the late 1980s and the 1990s

15 Patrick Heron, ['The British Influence on New York'], *Guardian*, London, 10, 11, 12 October 1974

16 Clement Greenberg, letter to Patrick Heron, 17 August 1958, Heron papers

17 Hilton Kramer, letter to Patrick Heron, 21 April 1959, Clement Greenberg Archives, Smithsonian Library, quoted in Andrew Wilson, 'Between Tradition and Modernity: Patrick Heron and British Abstract Painting 1945–1965', unpublished PhD thesis, Courtauld Institute, London 2000

18 Separate conversations with Katharine and Susanna Heron, 23 January 2001 and 27–8 December 2000

Chapter 5

1 Patrick Heron, *The Colour of Colour*, E. William Doty Lectures, College of Fine Arts, University of Texas at Austin, 1979, p.19 et al.

2 Ibid., p.30

3 Martin Gayford, interview with Patrick Heron in Sylvester 1998, p.42

4 Patrick Heron, *Braque*, London 1958, p.5

5 Alan Gouk, 'Recent Paintings', *Patrick Heron*, exh. cat., Barbican Art Gallery, London 1985, reprinted in Sylvester 1998, p.147

6 Patrick Heron, 'Constable: Spatial Colour in the Drawings', *Constable: A Master Draughtsman*, exh. cat., Dulwich Picture Gallery, London 1994, reprinted in Gooding 1998, pp.209–17. Naturally, while he was involved with this exhibition, Patrick Heron took the opportunity to fire off a letter to Peter Brooke, Secretary of State for National Heritage, asking for state funding for the gallery, 26 March 1993 – nothing came of it

7 Katharine Heron, letter to the author, 30 August 2001

8 Patrick Heron, conversation with the author, February 1991

9 Patrick Heron, preface to *Patrick Heron on art and education*, University College, Bretton Hall, Wakefield 1996, pp.74–5. In writing to the *Independent* criticising National Curriculum Council plans to teach art to children in their classrooms instead of in dedicated art rooms, Heron had said: 'Lay off, leave the professionals alone for once ... No minister has ever before presumed to interfere so flagrantly with the work of great experts.' To which Clarke replied, in part: 'I am not too attracted by Mr Heron's advice to leave it to "the great experts", by which he appears to mean himself.'

10 If it was not known that Heron's prose style was modelled on his reading of T.S. Eliot, one would guess it from the cadences of this passage alone

11 Alan Gouk, 'Recent Paintings', *Patrick Heron*, exh. cat., Barbican Art Gallery, London 1985, reprinted in Sylvester 1998, p.150

12 Susanna Heron, conversation with the author, 27–8 December 2000

13 Katharine Heron, conversation with the author, 22 January 2001, and email, 15 May 2001

14 Hugh Stoneman, conversation with the author, 18 May 2001

15 Susanna Heron, conversation with the author, 27–8 December 2000, and Katharine Heron, conversation with the author, 16 May 2001

16 Leslie Waddington, information accompanying invitations to the posthumous exhibition of Patrick Heron's last gouaches, May 1999

Further Reading

BRAGG, Melvyn (editor/presenter) and READ, John (producer/director), *Patrick Heron* (video recording of a London Weekend television production in association with RM Arts), London 1986

FEARY, Julian, and TOOBY, Michael (eds.), *Colour in Space: Patrick Heron: Public Projects*, Tate, London 1999

GOODING, Mel, *Patrick Heron*, London 1994

HERON, Patrick, *The Changing Forms of Art*, London 1955

HERON, Patrick, *Ivon Hitchens*, Harmondsworth 1955

HERON, Patrick, *Braque*, Faber Gallery, London 1958

HERON, Patrick, 'The Ascendancy of London in the Sixties', *Studio International*, December 1966

HERON, Patrick, 'A Kind of Cultural Imperialism', *Studio International*, February 1968

HERON, Patrick, 'The Shape of Colour' (text of the Power Lecture in Contemporary Art delivered in Sydney 1973), *Studio International*, February 1974

HERON, Patrick, ['The British Influence on New York'], *Guardian*, London and Manchester, 10, 11, 12 October 1974

HERON, Patrick, *The Colour of Colour*, E. William Doty Lectures, College of Fine Arts, University of Texas at Austin, Texas 1979

HERON, Patrick, in conversation with Michael McNay, *Intimations of*

Landscape (presented as 24 slides and 1 sound cassette), Lecon Arts, London 1987

HERON, Patrick, and GOODING, Mel (ed.), *Painter as Critic: Patrick Heron: Selected Writings*, Tate, London 1998

KNIGHT, Vivien, and HOOLE, John (ed.), *Patrick Heron*, exh. cat., Barbican Art Gallery, London 1985

SYLVESTER, David (ed.), *Patrick Heron*, exh. cat., Tate, London 1998

WILSON, Andrew, 'Between Tradition and Modernity: Patrick Heron and British Abstract Painting 1945–1965', unpublished PhD thesis, Courtauld Institute of Art Books Library, London 1999

WILSON, Andrew, *Patrick Heron: Early and Late Garden Paintings*, exh. cat., Tate St Ives 2001

Copyright and Photographic Credits

Index